Vasarely

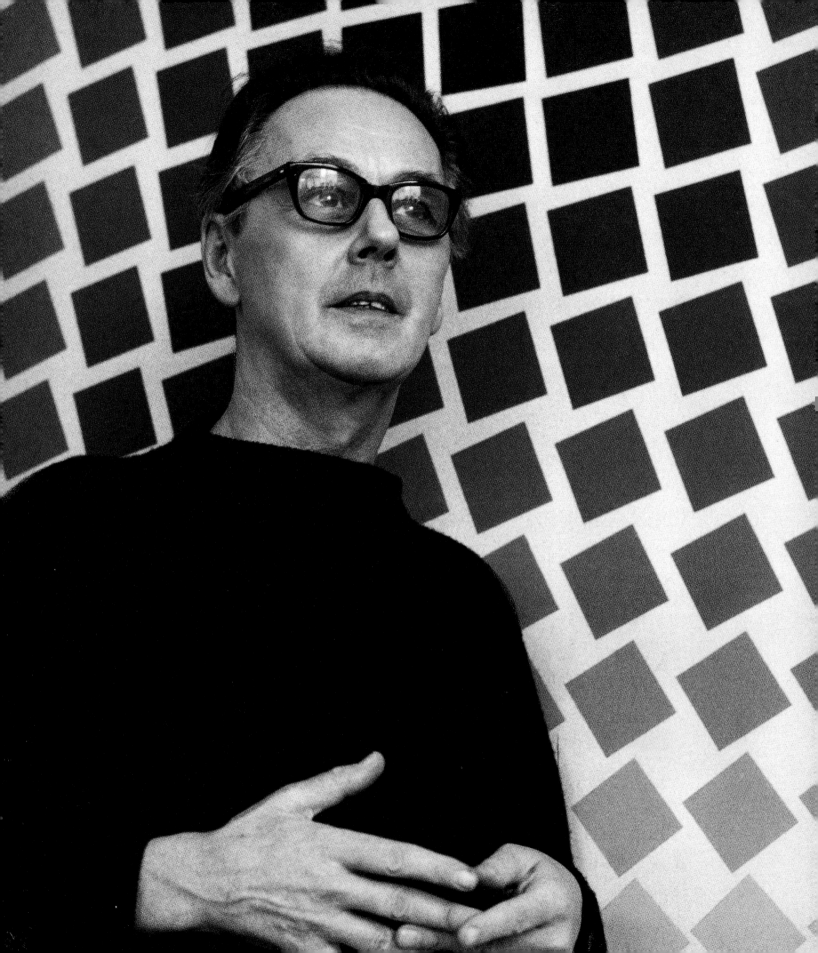

Vasarely

Robert C. Morgan

Naples Museum of Art

FLORIDA

George Braziller

NEW YORK

To my students —R. C. M.

Published on the occasion of the exhibition "Victor Vasarely: Founder of Op Art"
organized by the Naples Museum of Art in Florida.

For information, please address the publisher:
George Braziller, Inc.
171 Madison Avenue
New York, NY 10016

Library of Congress Cataloging-in-Publication Data:
Morgan, Robert C., 1943–
Vasarely / Robert C. Morgan.
p. cm.
"Published on the occasion of the exhibition 'Victor Vasarely: founder of Op art'
organized by the Naples Museum of Art in Florida"—Includes bibliographical references.
ISBN 0-8076-1538-2
1. Vasarely, Victor, 1906–1997—Exhibitions. 2. Optical art—
France—Exhibitions. I. Vasarely, Victor, 1906–1997. II. Title.
N6853.V3A4 2004
709'.2—dc22 2004019462

Frontispiece: Vasarely, in 1966, with his painting *C.T.A. 105-OR*
(1965, acrylic on canvas, 63 x 63 in. [160 x 160 cm], collection unknown).

Endpapers: Detail of an untitled three-dimensional metal sculpture by Vasarely
in anodized aluminum, n.d. Photograph by Werner Hannappel.

Designed by Rita Lascaro

Printed and bound in Singapore

First edition

Contents

Acknowledgments

It was with much pleasure that I accepted the invitation to write about Victor Vasarely from Myra Janco Daniels at the Naples Museum of Art in Florida and the legendary New York publisher George Braziller. I am enormously grateful to both of them. I also thank Dianne Sponseller, assistant to Myra Daniels, who provided generous support on countless details; Mary Taveras, who edited the manuscript with dedication and talent; and Rita Lascaro, for her design expertise. The assistance of Agi Clark, Richard Gallin, and Michelle Cone proved invaluable in substantiating factual details. I credit Michèle-Catherine Vasarely for her excellent translations of Vasarely's writings, for her own superbly gifted writing, and for her help in bringing photographs and various important documents easily within my reach. This publication would not have been possible without her generosity and commitment. Finally, special thanks to Jung Wook Rim.

Robert C. Morgan

Foreword

Victor Vasarely holds a special place in the history of twentieth-century art. Regarded as the father of Op art, he was an artist of remarkable inventiveness who not only made important contributions to the evolution of abstract art, but also bridged the gulf between mid-twentieth-century art and the computer age. "Victor Vasarely: Founder of Op Art" offers a fresh and in-depth look at this groundbreaking artist.

The exhibition would not have been possible without the generosity and dedication of Michèle-Catherine Vasarely, the artist's fiercely devoted daughter-in-law, who is Chairman of the Board of the Vasarely Foundation in France. Mme Vasarely is a self-taught scholar and a woman of courage and humor, whose eye for art is impeccable. I first became acquainted with her a couple of years ago when she visited me at my office and invited me to view some of Vasarely's most thought-provoking paintings with her and Luis Rojas. The need for a show about his work, which influenced a generation of artists here and abroad and which is increasingly finding new audiences, soon became apparent.

We are grateful to the many institutions and individuals in Europe and throughout the United States who have lent their works to this exciting exhibition, the first Vasarely retrospective in this country since the 1960s.

There are many other people whose contributions are greatly appreciated. Luis Rojas served as an invaluable collaborator and coordinator. Professor Robert C. Morgan's insightful text underscores Vasarely's considerable accomplishments and captures his unique journey from the graphic arts to his pioneering abstract kinetic art. Credit goes to Naples Museum of Art Director Dr. John Hallmark Neff and his staff for their work on this exhibition and to our Senior Writer and Editor James Lilliefors. Publisher George Braziller and editor Mary Taveras are commended for producing this fine book. Thank you all for helping us to make this retrospective a reality. We hope that viewers and readers alike find it rewarding.

Myra Janco Daniels
Chairman and CEO, Naples Museum of Art

Man of Art, Man of Science

Vasarely was a visionary, a creator, a man of science. Conscious of living in a pivotal epoch, he understood before everyone how technology would radically transform our world, and he projected this intuition into his creations. Preaching the gospel of interdisciplinary collaboration, he declared that "all architects, painters, sculptors must learn to work together. It is not a matter of negating the masterpieces of the past, but we have to admit that human aspirations have changed. We must transform our ancient way of thinking and conceiving art; particularly in the cities we must share it, make it accessible to all. Art must be generous."

Vasarely invested all his strength in the realization of his ideas and enjoyed during his lifetime a degree of fame rarely experienced by artists. The 1970s witnessed the climax of his glory. Vasarely became the unassuming celebrity of the American art world, the rock star of the multicolored dance of the circle and square, and his home remained a public place thereafter. In an instant his austere, monastic life was transformed, and he became a sacred monster of art, culture, and media. He was not prepared. Overwhelmed by his success and the attention that came with it, he was barely able to manage the extraordinary situations that followed.

Very soon the Op wave reached beyond the art world and appeared in clothing, shoes, textiles, and jewelry, thrusting him into the center of a uniquely postmodern whirlwind of instant internationalization and frenzied mass commercialism.

But Vasarely flew high, solitary, and independent, dominating his surroundings with a stately presence and undaunted rigor. He was almost too much of everything. An overpowering magnetic force emanated from within him. He was one of those beings born to make us believe again in man. His generosity was legendary, and as if all these qualities were not enough, he was handsome and armed with an irresistible charm that he displayed until the end. He adored animals, had many pets, and was a firm believer in leading a very regular and healthy life, devoid of superfluous luxuries. Fascinated by nature, he would scrutinize the bushes, trees, and leaves from his workshop's enormous bay windows, enraptured by their overlapping contours, their synchronous movement, the endless permutations of the inherent mathematical logic of living things, the poetry of the phenomena of a life, all of which were so deeply rooted in his work. He always thought that man would better comprehend humanity by dedicating more time to observing nature.

Vasarely never touched a computer. He was in his eighties when the first rudimentary personal computers entered the market. And yet, the day after he passed away, the headline of one of France's most prestigious newspapers read "The Father of the Computer Dies."

I will never forget his reaction when I showed him a new machine I had just discovered—the fax. There we were, the great visionary and I, looking at this electronic box magically giving birth to the handwriting of a friend on the other side of the Atlantic, as if we were witnessing an apparition. Vasarely's expression was a mix of amazement, excitement, disbelief, and pride—much like a child who had just achieved something he had dreamed of but of which he had not been quite sure he was capable. Then he broke the silence with his usual humor and said, "Finally, my time is coming . . . a little late for me but fortunately not for my work."

Many times I wonder what he would be doing today, with the aid of the technological tools he mimicked in his mind long before they existed. He would almost certainly be doing just the same: reaching far into the unknown, far into its intoxicating mystery.

Michèle-Catherine Vasarely

Vasarely

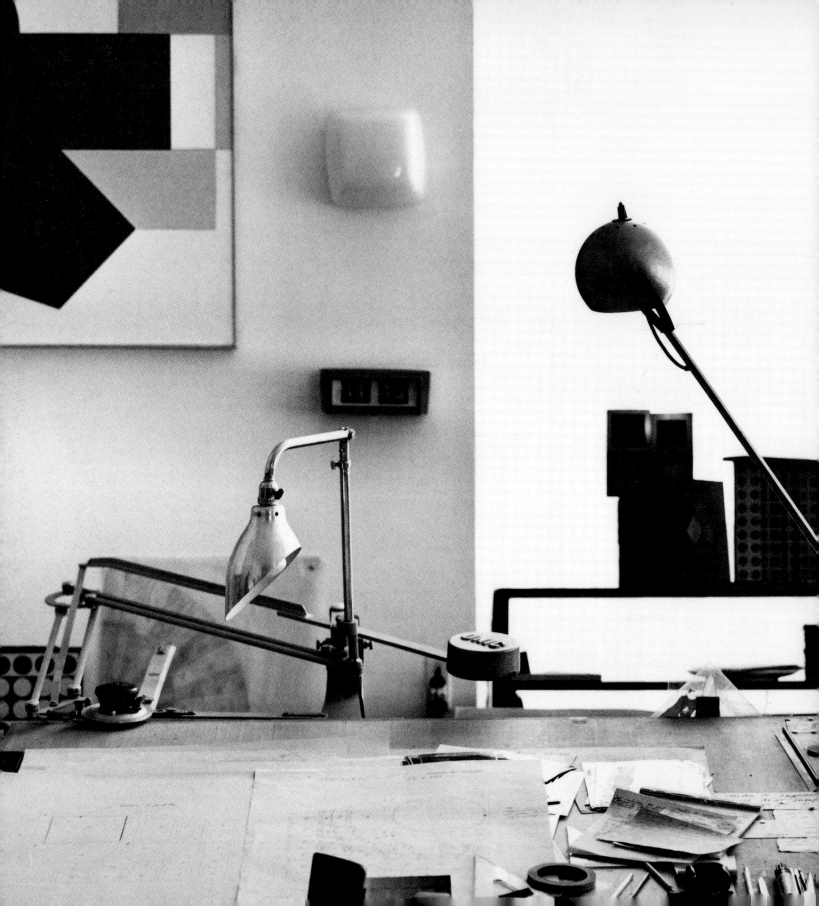

Victor Vasarely (1906–1997) is one of the greatest innovators among artists of the twentieth century. Through his visual language of modular forms, Vasarely crossed the threshold into the computer age long before Macs and PCs became available. His journey from graphic design to geometric painting, soon followed by the invention of his *alphabet plastique*—the system he used to create the precise, optical spaces for which he is best known—reveals one of the most daring and significant intellectual trajectories by an artist to establish a universal visual language. Vasarely believed that art could be read as well as seen, that it could become an effective tool in making necessary and vital connections between the individual and the collective consciousness. To do so, art needed to transcend the prescribed limitations of class privilege and become a common resource that would contribute to the quality of people's lives. In this sense, Vasarely was a utopian artist. Perhaps this is why his work was, during his later career, refuted by some and misunderstood by others. Vasarely, however, is now beginning to reemerge as an artist far ahead of his time.

Vasarely's reputation in America was closely tied to "The Responsive Eye," a major exhibition at the Museum of Modern Art in 1965.[1] While his work had been shown in 1959

Vasarely's work table. Annet-sur-Marne, ca. 1970s. Photograph by Werner Hannappel.

at the inaugural exhibition of the new Solomon R. Guggenheim Museum, it was the exhibition at MoMA that brought him worldwide recognition. Within a short time, he would be acknowledged as a major innovator and instigator of Op art.

Organized by William C. Seitz, "The Responsive Eye" was one of the truly groundbreaking museum exhibitions devoted to avant-garde Modernism of the 1960s. It gave New Yorkers an opportunity to see works by international artists involved with opticality and kineticism in the context of a larger survey. In addition to Vasarely, the 1965 exhibition introduced a wide range of artists, many of whom were either emerging on the international scene or were still, at the time, relatively unknown. Among the nearly one hundred artists associated with the exhibition were Yaacov Agam, Richard Anuszkiewicz, Piero Dorazio, Robert Irwin, Julio Le Parc, Larry Poons, Bridget Riley, Frank Stella, Tadasky, Wen-Ying Tsai, and Yvaral—all of whom were under forty years of age. These artists were exhibited beside established figures, such as Josef Albers, Max Bill, Carlos Cruz-Diez, Wojciech Fangor, Paul Feeley, Gego, Ellsworth Kelly, Alexander Liberman, Morris Louis, Agnes Martin, John McLaughlin, François Morellet, Kenneth Noland, Leon Polk Smith, Ad Reinhardt, and Luis Tomasello. The curator also chose to include three important artist-groups whose works were specifically involved with optical and kinetic concerns: Groupe de recherche d'art visuel (GRAV) (Paris), Gruppo N (Padua), and Equipo 57 (Spain).[2]

In many ways Op art—the movement with which Vasarely's name and reputation are aligned—was the first truly international art movement of the post–World War II era. It was in this context that Vasarely came to the forefront of international critical attention—not only for his startlingly precise, often hallucinatory images but also for the nature of his ideas, which served as the underpinning for bringing science and technology into art. By the end of the 1970s, however, when Vasarely's influence was on the wane, Op art could no longer compete with more attention-getting phenomena in the American art world: Pop art, Minimalism, Conceptual art, body art, Earth art, and so on. As an artist given to high-minded humanism and theoretical ideas, Vasarely was ironically criticized as a link to the utopian idealism of the early twentieth century.[3] European movements, such as the Bauhaus and Constructivism, were no longer considered avant-garde. The American art world of the late 1970s had become more interested in Post-

Modernism, the continued influence of Pop art as exemplified by Andy Warhol, and the performance art made famous by German Conceptual and Performance artist Joseph Beuys, rather than in Vasarely's "poster art," as his work was too often designated. Outside France, Vasarely was seen as a technician whose main virtue was the decorative appeal of his images.

This turn of events coincided with the rise of marketing interests in contemporary art in the late 1970s. As the potential for investment in the works of living artists became clear, contemporary art was promoted as investment-worthy, the same way that historical objects from the Renaissance or from the era of French Impressionism were. The design and sale of art multiples also began to play a role in developing a new clientele for art. Herein lies one of the most controversial aspects of Vasarely's career. While the artist was interested in a democratized form of art—that is, art that could exist in a middle-class context, in homes where discretionary income was not the sole criterion for owning art—what gallerists and dealers in both Europe and New York saw was an opportunity to exploit Vasarely's appeal to a mass-market audience by creating signed and numbered editions of his prints and Plexiglas objects. What began to happen, of course, was that the marketing of his prints and multiples discouraged collectors from buying.

Within a few years after "The Responsive Eye" exhibition, Vasarely multiples flooded the market, showing up not only in galleries devoted to prints and multiples, but in museum shops, greeting card stores, and the like. Brightly colored, mathematically based images, such as those from the popular Alphabet Plastique, Gestalt, or Vega series, had popular visual appeal. Some critical observers referred to the prints and multiples as "optical illusionistic games," but the artist maintained that he was forging a new direction for art by engaging in an unprecedented experiment that would bring art into the twenty-first century. He was interested in making a new social form of art—available to everybody.[4] While some saw Vasarely's claims for his art as naive, one could just as easily argue that they were completely consistent with the socialist idealism he was exposed to before leaving Hungary in 1930. Today, however, regardless of one's views of his socialist ideals, Victor Vasarely stands as a visionary, the artist from wartorn Central Europe who led the way in bringing art into the age of the computer.

Formation and Influences

Some artists know what they want right from the beginning and pursue it assiduously throughout their lives. The path of other artists is less certain. It is not so much a matter of possessing self-confidence than of being fortunate enough to have the right set of circumstances. In Vasarely's case, the circumstances of his native Hungary—political, social, economic, ideological, historical, and personal—made it difficult for the young artist to know exactly which way to turn. Initially, he was oriented toward science rather than art. But by 1927, at the age of twenty-one, Vasarely made a decision that took him to another place intellectually, one that he had never considered while growing up in the city of Pécs or while studying medicine in Budapest: he suspended his studies at the University of Budapest's School of Medicine.

Despite having to put aside his medical training, Vasarely went on to conduct his own investigations in the natural and physical sciences, and in the fields of cybernetics and advanced technologies. His desire was to understand the theories of relativity and quantum mechanics and the scientific hypotheses in the field of astrophysics, and thereby acquire an objective understanding of reality. He read voraciously the works of Albert Einstein, Werner Karl Heisenberg, Neils Bohr, and Norbert Wiener. On his own, Vasarely came to the conclusion that these sciences had reached the limits of what could be explained and that art offered a way, through plastic equivalents, of making scientific models visually comprehensible.

As with the seventeenth-century French mathematician and philosopher Blaise Pascal and later with the twentieth-century language philosopher Ludwig Wittgenstein, Vasarely discovered the value of feeling and intuition when confronted by concepts that were, in themselves, systematically unexplainable. He had learned, by his early twenties, what it takes others a lifetime to learn: to trust one's intuition when all explanations fall short. Thus, he came to the remarkable realization that "the two creative expressions of man, art and science, meet again to form an imaginary construct that is in accord with our sensibility and contemporary knowledge."[5] Was Vasarely's discovery a result of the historical circumstances that bore down upon him? Was he forced to take what he knew and, by augmenting his knowledge, move in a new direction? Perhaps. But there is more

to the story. To realize something of major significance is one thing, but to be able to instrumentalize that realization, to give it adequate form and function, is something else. For this, Vasarely needed guidance.

He found it in the coffee houses along the Danube, which, regardless of the season, were perpetually filled with people discussing politics, history, international affairs, psychoanalysis, social theories, economic developments, and, of course, avant-garde art and music. Here, the latest advances in science and technology were discussed, not only in terms of their disciplines but also in terms of whether or not they could improve the quality of life. It was in this atmosphere of open-minded discussion that Vasarely learned about the Bauhaus in Dessau, Germany (where it had moved in 1926 from Weimar) and about the Hungarian artist László Moholy-Nagy, who in 1923 had been appointed to teach at the Bauhaus. Vasarely also learned about the formation of a school of fine and applied arts in Budapest, based on ideas similar to those of the Bauhaus, called the Mühely (the Workshop).

Founded by Sándor Bortnyik, who had lived in Weimar for two years before returning to Budapest in 1925, the Mühely Academy offered courses that synthesized new techniques and social ideas with art, particularly with the graphic and industrial arts.[6] Although Bortnyik had never actually been a student at the Bauhaus, he was deeply affected by conversations with both students and teachers there and, ultimately, by the principles for which the school stood. He wanted to translate these ideals in a way that would be relevant to students in Hungary, inspiring them to think about art as a means for social change and to regard the artist as an advocate for the transformation of values. Bortnyik believed that art needed to move from archaic conventions to a more optimistic perspective on contemporary reality through a commitment to social change. He believed this could happen through the application of innovative techniques and progressive ideas. These were the essential goals of the Bauhaus, and, through Bortnyik, they would become the essential goals of the Mühely.

In 1929, after a two-year hiatus upon leaving the University of Budapest, Vasarely enrolled at the Mühely. This seemed to him the most expedient way of putting himself in touch with the advanced concepts that interested him and to which he adhered. At the Mühely, Vasarely explored a number of diverse visual forms including abstraction,

in which he would be fully immersed by 1945. In the meantime, he became involved with the folk traditions of Hungary, with the narrative tales and images of the forests of Transylvania. Like the Uruguayan Constructivist Joaquín Torres García (who also went to Paris to practice art), Vasarely saw the value of establishing a bridge between the traditional cultures of common people and new technologies that would allow these traditions to become part of the contemporary world. Vasarely intuitively understood the importance of preserving these traditions in relation to advanced art. Another important influence from this time was the inspired thinking of the Hungarian Constructivist Lajos Kassák.[7]

The world of art was expanding before Vasarely's eyes. The same year he began his studies at the Mühely, 1929, he painted his remarkable *Études Bauhaus* (plate 1). Using rectilinear blocks of color within a quadrilateral, Vasarely created four compositions, each defined by geometric form and color relations. This would become his launching pad, the foundation for the direction he eventually pursued. The young artist was ready to move to the next level in his education and self-discovery, and it would be through the graphic arts that he would take this next step. However, as he confronted the realities of the advertising industry in Paris and the influence of French culture, which inevitably merged with his Hungarian past, he found that his path was not without detours.

Paris: Early Years

By the time Vasarely arrived in Paris, he carried with him an entire arsenal of visual, technical, aesthetic, and scientific knowledge and experience. His training at Sándor Bortnyik's Mühely—the Budapest counterpart of Bauhaus ideas—was crucial in preparing him for what lay ahead. There, he had learned the principles of geometric abstraction from the Bauhaus perspective and was aware of the theories and teachings of artists such as Wassily Kandinsky, Paul Klee, Albers, and Moholy-Nagy—all of whom had either studied or taught at the Bauhaus in either Weimar or Dessau. Through his professional contacts and training at the Mühely, new doors of perception were opened to him, new ideas that enhanced his discovery of art in the City of Lights—still, in 1930, the center of the art world. Vasarely was now in a position to find new syntactical applications, new permutations in the field of graphic art. He knew that to pursue what he had learned would require strong commitment, assiduity, and clarity of intention. It would require determination not only to excel in terms of creating innovative visual forms but also to show how graphic design might function as a social application—to reveal, that is, its potential for achieving utopian social ideals. Art had to have a purpose and a function beyond itself. It should reach into the very fabric of society, according to Vasarely, and offer a new and vital optimism, an incentive for social change.

Paris appeared to be the right environment for such socially minded art. Given the excitement in the streets—the posters, advertisements, and other visual stimuli—Vasarely saw possibilities there for transforming aspects of everyday life into clear visual signs. From his apprenticeship at the Mühely in Budapest, he understood the power of graphic design; he knew that the way an image is constructed could either transmit meaning or create ambiguity. To achieve something significant, an artist needed a strong sense of visual acuity and a desire to provoke positive change.

Initially, Vasarely worked for a variety of advertising agencies, but there was little to challenge him beyond the reality of daily work. He was not satisfied working only on the level of client commissions or doing purely technical layouts for the company boss. As a graphic artist trained by the Bauhaus-inspired Bortnyik, Vasarely had been instilled with the desire and the motivation to transform visual images in a way that would chal-

lenge the role of the artist. Devoting his days to his work in advertising, and his nights to his art, he was constantly searching for more time to do his own work. He was also beset with trying to earn a living while at the same time making his way in the field of graphic design on his own terms. His goal was to make his night job his day job—a difficult task during the depths of the Great Depression.

Vasarely's aspirations as an artist determined to change reality are intimated in his 1934 *Autoportrait* (plate 2), in which he depicts himself with a beatific expression of sheer determination, as if he were encountering his own future and revealing his destiny as a visionary artist. Its appearance is far removed from the teachings of the Mühely. Executed in pastel, its style is reminiscent of fin-de-siècle Hungarian symbolism, the kind of self-portrait that could be seen in galleries representing Art Nouveau or Secessionist painting. This suggests a conflict between Vasarely's need to express himself, on the one hand, and his pursuit, on the other, of social ideals infused with metaphysical meaning. One of the interesting contradictions in Vasarely is the coexistence of his romantic interest in the Hungarian countryside with his desire to be precise and impeccable in grasping the mathematical structure of both representational and non-objective space. While he tended toward the Bauhaus method of objectivity, the romantic aspect of his work was never completely erased.[8]

More indicative of Vasarely's stylistic direction is *Arlequin* (1936–52, plate 7), a painting that signals the kinetic and optical concerns that would emerge in his work nearly two decades later (thus the sixteen-year span of the work's date). Here, we see the figure of a Harlequin balanced within the stratosphere of a systematically colored grid—a skewed, biomorphic grid—which the figure emerges from, then disappears into. Vasarely was concerned primarily with the design. He used the grid—the background of the brilliant optical design—as a ploy to deliberately distort the figure. The theme of the *Arlequin* had both Hungarian and French origins, but it is intended less as an expression of this theme than as a revolutionary design—both as a formal way of seeing the figure within the ground, and as a method for coming to terms with how art could function eloquently within the public realm. One sees within the belly of the dancing Harlequin the formal theme that would become predominant in the Vega series of the 1960s. This spherical illusion is precisely what Vasarely would employ in his

larger, much grander, abstract canvases—the optical art with which he would ultimately be identified.

Another graphic work from the early Paris period, *Tigres* (1938, plate 9) is unmistakably related to the Zèbres series that began in the decades of the 1930s and extended through the 1960s. What characterizes *Tigres* is the alternating contrasting colors, the rhythmic intervals of punctuating hues—the red, yellow, green, and black stripes—that contribute to the overall effect and are centered like a glowing ember within a darkened field. Here Vasarely makes clear his subliminal power to engage the image as an expressive conduit while at the same time giving the structure and composition of the work its ineffable stability, its equivocal tension and balance.

In 1940—after a decade of working for graphic designers and advertising agencies in Paris—Vasarely turned to the still-life motif, but in a way that was ineluctably radical and truly Modernist in its sensibility. Two examples are *Étude en Jaune* (plate 10) and *Étude en Rouge* (plate 11)—both from the same year, created nearly one after another and each a kind of tour de force in the application of semiotics to graphic design. The structural concept is consistent from one work to the next, even though their subject matter differs. They are, most assuredly, works intended to illustrate formal ideas. Both are less about painting in the avant-garde sense than Formalist exercises that ultimately emit semiotic closure—systems of signs, not without humor, that compound the various meanings of the respective colors to which the images refer, namely, yellow and red.

Later, Vasarely would claim that what makes a work of art kinetic is not just the formal vibration of the forms and colors, but how one's eye moves among the various components—the diversity of subject matter, whether representational or abstract—instilled within the picture plane. One might say that the optical effects are created not merely by Formalist means but through a careful articulation, a subtle divergence of subject matter. It is within the combination of these factors that the image is capable of structuring the way we perceive meaning. Simply put, the formal coherence of the surface is what transmits coherent content to the viewer.

In many ways the signs alluding to the colors portrayed in *Étude en Jaune* and *Étude en Rouge* carry a certain aura of sentiment, perhaps even naiveté. In *Étude en*

Jaune, for example, a bright yellow sun at the top of a highly finished picture plane illuminates a carefully composed sequence of images ranging from a horizontal stalk of bamboo to a vertical sunflower to a diagonal ear of corn. One wonders if the generalized portrait of an Asian male head with a smaller head emerging from its left ear is merely a surface phenomenon or whether it implies a racial stereotype that people from the East can be identified according to the color of their skin. It is interesting to speculate on the reception of this image in 1940 compared with its reception today among sophisticated viewers with a heightened degree of postcolonial awareness.[9]

As its companion piece, *Étude en Rouge* displays the same laudable degree of surface perfection and accomplishes much the same. Linear devices are less evident in this painting, though, with the composition succeeding more in terms of its circular or curved patterns—a parrot, a carp, an apple, a rose, a heart, lips. It includes another generalized stereotype, this time of an American Indian wearing a headdress, which, given its diminutive size and profile, looks innocuously emblematic in comparison with the larger, orientalized figure represented in *Étude en Jaune*. Without making apologies, these were signs of the times. And in his defense, Vasarely was less concerned with racial stereotypes than with searching for an aesthetic integration of signs that might eventually convey both social integration and cultural exchange to the viewer, not from a Western hegemonic position, but from a more generalized viewpoint. He had moved to Paris at the start of this search, and in the 1960s, twenty years after he painted *Étude en Jaune* and *Étude en Rouge*, it would lead him to his notion of *Folklore Planetaire*, or "Global Folklore," as a humanist, nonisolationist, and antinationalist extension of his evolving abstract vocabulary—a notion that was never intended to be racially demeaning. Vasarely was too much a visionary to indulge in the trivial.

Another approach to the semiotic still life is revealed in *Étude en Multicolore* (1941, plate 12). Here, various primary and secondary colors are interwoven with an absurd juxtaposition of subject matter—a ribbon, a bow, a candle, a camera, a feather, a baby, a powder puff—apparently giving weight to the concept of a figurative vocabulary used in abstract terms. As shown by the Russian Formalists—such as the literary critic and novelist Viktor Shklovsky and the structural linguist Roman Jakobson two decades earlier—signs and symbols, even when realistically portrayed, constitute an abstract

vocabulary, whether in poetry, film, painting, sculpture, dance, or theater. If the meaning of the signifying elements is made clear by their association with one another, then the composition itself could be considered representational, that is, representational in that it signifies a structure that is abstract. Thus, the scientific methodology that guided Vasarely when he left medical school in the late 1920s was still at work. Now it was being applied to how figurative signs are linguistically constructed. One might say that at this juncture—with *Étude en Multicolore* and the brilliant *Le Cirque* (1942, plate 13)— Vasarely had reached a kind of semiotic apotheosis in which he understood the sign-values of realist subject matter as being ultimately abstract. On a purely theoretical level, this is perhaps the reason Vasarely later turned to abstract painting and thus made the immense contribution that he did to Modernism. For this, of course, he is known but also equally misunderstood.

Vasarely's first important exhibition in Paris—the inauguration of the Denise René Gallery—opened in 1944, nearly a decade and a half after his arrival in France.[10] Vasarely showed only drawings and graphics—close to 150 works in all. The exhibition was held one year before the end of World War II, but even so, the critical reception was notable both for Vasarely and for Denise René. The success of the exhibition further prompted Vasarely to devote himself to painting, and to abandon his idealistic view of the graphic arts as the sole means of communicating socialist values.

After his initial show, he more or less left behind the graphic approach. In 1946, he painted *La Cuisine Jaune à Cocherel* (plate 14) and *La Maison* (plate 15) in which the color planes are shaped by the artist's desire to discover his own sense of plasticity. The following year we see a brief return to realist subject matter in *Artiste Devant Sa Toile* (plate 16). Then came *Ézinor* (1949, plate 19), a black-and-white painting of bladelike forms and quadrilaterals, clearly influenced by Alberto Magnelli of the Forma Una group in post–World War II Italy. Vasarely's introduction to abstraction as a painterly practice brought the work of a new group of artists to his attention, from Magnelli to Sophie Taeuber-Arp, from Auguste Herbin (founding member of Abstraction-Création) to Piet Mondrian and the architect and painter Le Corbusier. A beautiful painting soon followed: *Mar Caribe* (1950, plate 20), a curvilinear, geometric work of enigmatic ingenuity and elegant simplicity.

Within a few years of Vasarely's commitment to abstract painting, he was included in three important exhibitions in Paris: "Salon des Surindépendants" (1945 and 1946), "Salon des Réalités Nouvelles" (1947), and again at the Denise René Gallery in an exhibition entitled "Tendances de l'Art Abstrait" (1948)—only this time the works shown were paintings, not graphics. Vasarely was now on the cusp of his rise to international attention.

Transitions

Vasarely's exposure to the Parisian art world through the Denise René Gallery was a crucial factor in his artistic development. The gallery was also an important vehicle in making him known at a time when his work was increasingly recognized by critics and followers of the new abstract art. By the late 1940s, Vasarely had come into contact with some of the leading European abstract painters. He was influencing others as well as picking up ideas from his colleagues, usually transforming what he saw into something entirely his own.

Vasarely did not really commit to painting until his early thirties.[11] Much of the early figurative imagery with which he had experimented in Paris would later be dubbed by the artist as his "false routes." It took him a while to come into his own. Until then, he pursued his career as a graphic designer—a highly principled decision on his part, based on his belief that art should be a democratic venture and not isolated in museums.

Given his early experience at the Mühely, it was clear to Vasarely that the history of art needed to escape its elite status and move into a more general social context. His dictum: "The art of tomorrow will be a common collective treasure or it will not be art at all."[12] In the late 1940s and 1950s he began to envision how the latest communications technologies could be applied to his imagery—an idea not so distant from that of his Hungarian predecessor Moholy-Nagy and also shared by the Russian Constructivist Naum Gabo. Even so, Vasarely pursued his own direction, making his own aesthetic decisions. He advanced his concept of art as existing in a broader social context by giving his paintings (and later his multiples) a pictorial meaning that exceeded the limitations of pure design and reached deeply into the psychology of perception. Earlier motifs, such as the Zèbres series—which he continued to expand and develop with new variations and permutations in his later work—were, for Vasarely, fundamentally abstract paintings in spite of their representational subject matter. Ultimately, Zèbres would prove instrumental as the artist moved from his profoundly reflective black-and-white paintings of the 1950s and early 1960s into the colorful kinetic and optical works of the late 1960s and beyond.

The transitional moments in Vasarely's career—from his early thirties in Paris to his late forties, when he left graphic design to pursue abstract painting—constitute a series

of remarkable advances. He moved from a highly unique style of figurative representation to a compositional form of geometric abstraction. Although he self-effacingly referred to his early graphics as "false routes," in fact, they were not. They were no less relevant than the Cubist period was to Duchamp or the Dada cutouts were to Hans Arp or the Purist paintings were to Le Corbusier. Vasarely's graphic period (1929–46) was a time of plastic experimentation, years spent in a visual laboratory, so to speak.

In *L'Échiquier* (1935, plate 5), for example, one can see virtually all the moves that Vasarely made over the next three decades. The composition within the image of the chessboard clearly reveals the major plays in Vasarely's aesthetic, perceptual, and conceptual repertoire, from kineticism to Op art.[13] Before the age of thirty, Vasarely had laid the cornerstone and presented the harbinger for what lay ahead. Whether Vasarely was fully conscious of what he was doing in *L'Échiquier* is, of course, another matter—one more related perhaps to the psychology of the creative process.[14]

Vasarely's vacations in Brittany's Belle-Isle, beginning in the summer of 1947, greatly influenced both his turn toward abstraction and his eventual decision to pursue non-objectivity in his painting. Of his initial experience at Belle-Isle, he wrote: "The pebbles, the sea shells on the beach, the whirlpools, the hovering mist, the sunshine, the sky. . . in the rocks, in the pieces of broken bottles, polished by the rhythmic coming and going of the waves, I am certain to recognize the internal geometry of nature."[15] The later phrase—"the internal geometry of nature"—articulates Vasarely's direction in painting.

For Vasarely, this was a kind of meditative turning point, a pivotal moment when the world—as he had perceived it until then—aligned itself with his desire for plastic expression. Without overstating the case, Vasarely was actively searching for a natural source for abstraction during his summer vacations at the magical Belle-Isle. The previously quoted passage from 1947 confirms this. While his observations are not so much scientific or theoretical as expressions of a romantic state of mind, they give a certain credibility to his discovery of a basis for abstraction in nature as one that is both experiential and empirical, as opposed to academic.

The series of black-and-white paintings from the same year—later referred to by the artist as the *blanche noir*—function visually as a hinge between literal representations of beach scenes and full-fledged abstract compositions. Although Vasarely was mov-

ing closer to a Concrete style of painting,[16] his direct reference to the external visual world in this series clearly indicates that he had not yet reached that stage in his development. He was still in need of source material. Later black-and-white paintings, such as the more ordered *Banghor* (plate 24), *Méandres Belle-Isle* (plate 25), and the extraordinary *Yapoura-2* (all from 1951), which were done four years after the artist's initial discovery, come even closer to his inevitable Concrete vision.

Vasarely's major breakthrough came two years later in the 1953 painting *Hommage à Malévitch*, dedicated to the pioneer abstract artist Kazimir Malevich. Here he moved from abstraction, as a process based on transforming external visual reality into a composition of shapes, to a new conceptual reality. It was as though Vasarely suddenly understood that abstraction could be not just a verb—in the sense of abstracting a composition from visual reality—but as a noun as well. In the latter case, the forms of abstraction possess their own internal parameters without relying on what the artist has actually observed in the natural world. Reality, in other words, could be conceptual as well; hence, the importance of Malevich's black square. This realization was liberating for Vasarely.

Hommage à Malévitch is a bilateral canvas consisting of solid geometric planes in black, gray, and white. In the left half of the painting is a skewed version of Malevich's black square in the form of a parallelogram, while in the right half there is a direct reference to Malevich's square. Vasarely's strategy was to give the squares equal weight and to present them so that they can both be seen simultaneously. It is at this juncture in Vasarely's work that his theory of kinetics comes to fruition. The black-and-white paintings begin to develop a systematic look based on multiple permutations and variations of his formal concept, which creates a kind of optical vibration on the surface. This becomes a fundamental aspect of his imagery from this point on. In 1954, for example, the year after he painted *Hommage à Malévitch*, Vasarely was invited to collaborate with the architect Carlos Raúl Villanueva on his first architectural manifestation at the University of Caracas in Venezuela. The Malevich concept became the formal basis of their design, helping to establish kineticism's principle of scale.

Another source of inspiration for Vasarely, reminiscent of his observation of natural phenomena at Belle-Isle, was a vacation he spent at Gordes-Crystal near Provence. The direction of his thinking is made evident in black-and-white paintings such as *Mindanao*

(1952–55, plate 26), *Yvaral* (1956–65, plate 27), and *Cassiopée-II* (1958, plate 28). They each have a strong connection to *Hommage à Malévitch* with their geometric or primary forms reduced to pure black and white (without grays) and their growing emphasis on Concrete form. This transition or evolution in Vasarely's painting can also be seen in three other black-and-white works: *Binaire* (1960, plate 29), *Riu-Kiu-C* (1960, plate 30), and *Naissance* (1964, plate 35), each of which possesses more optical elements than the work that preceeds it.

A theoretical turning point during this period of black-and-white paintings was the publication of "Manifeste Jaune" (Yellow manifesto) (1955), in which Vasarely outlines his concept of "plastic kinetics." For the advanced artist, "painting and sculpture become anachronistic terms: it's more exact to speak of a bi-, tri-, and multidimensional plastic art. We no longer have distinct manifestations of a creative sensibility, but the development of a single plastic sensibility in different spaces."[17] The manifesto was first presented at the Denise René Gallery during an exhibition that included works by Duchamp, Herbin, Man Ray, Alexander Calder, and Jean Tinguely. Vasarely's articulation of plastic kinetics revived many earlier ideas put forth by the Constructivists and members of the Bauhaus by advocating that "movement does not rely on composition nor a specific subject, but on the apprehension of the act of looking, which by itself is considered as the only creator."[18]

It was during this time that Vasarely also became involved in what he called "*photo-graphism*," the manipulation of painted black-and-white images through the use of photographic techniques. As he made clear in "Manifeste Jaune," the future of art does not lie in specific media such as painting or sculpture, but in any technical or formal medium—such as *photo-graphism*—that is capable of generating a kinetic means of seeing. In many ways, the artist's use of this new medium pointed toward a pixilated manipulation of imagery, even before the digital hardware became available. It also anticipated Vasarely's future interest in working with dematerialized pictorial spaces in which images float without attachment to material support—which, in turn, suggests the logical outcome of kineticism in art. To see things from a kinetic point of view is not necessarily about the literal movement of the form but about the kind of experience the viewer has in the process of viewing it. The viewer, in fact, has a role equal to that of the artist in the aesthetic process of receivership.

Innovator of Optical Art

The period between the mid 1950s through the late 1960s reveals a significant sequence of leaps in Vasarely's career. During this fifteen-year period, he brought a new level of achievement to his work as a participant in many important projects, commissions, and exhibitions. He defined his position by extending Concrete form into the realm of socially conscious art with a much-heralded emphasis on kinetic plasticism. He gave his work definitive form with clear purpose and direction. It was during this period of intense creativity that his reputation as a major international artist identified with Op art was firmly established.

Vasarely was the recipient of many awards, including the Chevalier de l'Ordre des Arts et Lettres in Paris, the Grand Prize at the VIII Arte Biennale of São Paolo, and the Grand Prix de la Gravure in Ljubljana, Slovenia (all awarded in 1965). He was given solo exhibitions in New York, Bern, Paris, and Brussels. In addition to his participation in "The Responsive Eye" at the Museum of Modern Art in New York, he was invited to participate in other collective exhibitions, such as "Documenta III" in Kassel, Germany (1964), and "Lumière et Mouvement" at the Musée d'Art Moderne de la Ville de Paris (1967). The same year of the Paris exhibition—an event that further solidified his role as the central figure of Op art[19]—Vasarely was selected to design the French pavilion at the Montreal world's fair, Expo '67. The same year, he was invited to exhibit in "10 Ans d'Art vivant, 1955–65" at the Fondation Maeght in the south of France and, most significantly, was given a retrospective at the Museum of Fine Arts in Budapest in 1969, the first major exhibition in his homeland since he left for Paris nearly forty years earlier.

The optical structures that first appeared in his *blanche noir* (black-and-white) prints, paintings, and objects at the outset of the 1950s had emerged in full force by the end of that decade. Through the use of new materials—including applications of industrial paint on aluminum, glass, and mosaic—and projection experiments with photography, Vasarely revealed the preeminence of his structural concept without limiting himself to a particular medium. In his *photo-graphisms,* the artist began to reproduce black-and-white drawings in reverse on sheets of plastic that he would then place over the original.

By shifting the positive and negative patterns in relation to one another, he would create a variety of kinetic and optical effects, often recording them on film. As his work moved into the 1960s, he completed several stately large-scale commissions in *blanche noir*, including a long horizontal, visually stunning mural in Neuchâtel, Switzerland, entitled *Aluminum Wand* (1963), in which illusory shapes appear between striations of wavy black lines. An equally impressive painting, *Yvalla* (1968, plate 38), one of the truly majestic works in black and white from this period, was completed the same year as his exhibition in Budapest.

While the *blanche noir* paintings continued to advance new ideas, forms, and materials throughout the 1960s, other formal developments concerned with the application and optical perception of color were evolving simultaneously. One example is Vasarely's reintroduction of systematic applications of color into his lexicon of optical and kinetic images, thus virtually defining the term *Op art* as a heightened phenomenal tendency in the further development of earlier forms of Concrete art. His brilliant and original inventions began to appear in two series of paintings: Alphabet Plastique and Folklore Planetaire. Each series was built on systematic color variables and standardized, modular forms. Alphabet Plastique began first and gradually evolved toward Folklore Planetaire, but as with all of Vasarely's series, it is difficult to pinpoint where one ends and the other begins. Marked by numerous crossovers, advances, retrogressions, pauses, and intervals, their evolution reveals Vasarely's constant experimentation.

Alphabet Plastique reached its apogee in 1965, the year some of his most important paintings were completed. Their structure can be analyzed in the following way: Each painting is based on fifteen root forms derived from the circle, the square, and the triangle. A total of forty variations of these root forms were then developed, which were painted with colors from six different color scales, each with twenty hues. Each unit within the grid, called a *unite plastique,* has a foreground and a background—a single figure-to-ground relationship.[20]

These series can be considered conceptual, but their conceptual structure is not divorced from the object—in this case, the painting—by which it is visually formed. One might refer to *Alphabet A B C,* for example, as a virtual painting in that the algorithmic concept that forms the basis of its structure exists independently of the work and is yet

integral to it. Theoretically, one could say that even if the material object were lost or destroyed, the algorithmic program could rebuild the painting. The alphabet of shapes, the conjugations between these shapes, and their individual hues would provide all the information necessary for the painting's restoration, even its translation into another dematerialized or three-dimensional form—a fact that did not escape Vasarely's attention.

Alphabet Plastique may indirectly owe something to Bauhaus concepts of structure and color theory, specifically those taught by Johannes Itten and later adopted by Josef Albers in his well-known series of paintings entitled Homage to the Square (begun in 1949). Vasarely enhanced the visibility of form and color by making both the subject of the painting and by making the painting in some way accountable to the logic of the artist's method. While Bauhaus ideas were clearly important to Vasarely's work, the artist was himself a major influence in bringing conceptually based structures to American art during the later half of the 1960s, specifically in relation to the architectonic cubes of Sol LeWitt.[21]

Predicting his arrival at a systematic approach to painting as early as 1953, Vasarely stated: "We now know that by following the successive steps of the processes of development of the unit-particle-wave, we arrive at the human phenomenon. Art can no longer have a divine explanation, just a beautiful and very materialistic one."[22] Here the artist puts forth the notion that "the human phenomenon" in art is a symbolic one, and by being symbolic in the scientific sense, art is capable of a twofold operation: a work of art can be decoded through its mathematical structure and, paradoxically, it can also communicate ideas beyond the visible aspect of its materiality, even beyond the known presence of the artist. It was precisely this realization that led Vasarely to his most radical idea since kineticism in 1953: the universal appeal of his Folklore Planetaire series as an extension of the algorithmic systems used in Alphabet Plastique.

Essentially, Vasarely wanted to free himself from being locked into a single approach to painting and was searching for a way to expand his color scale beyond the predictable permutations of a given system. He was interested in the sheer variety of shapes and colors that might function as a universal language and thus recall the folkloric culture of regions worldwide. His intention was to conjugate colors, shapes, and patterns in a manner that would transmit basic human values to people outside the art establishment, com-

mon men and women. This was essentially a socialist view of art—a return to the democratic idea of aesthetics entertained years earlier in Budapest. We see the results in paintings such as *Folklore-11* (1963/64), where Vasarely departs from the predictable system of Alphabet, and again, from a different point of view, in *Dom Bleu* (1967).

Later, in the early 1970s, we see examples of a more complex matrix in *Orion-K* (1972) and *Folk-Lor* (1973). In each case, the overall patterning suggests not only an optical illusion but also an overlay of thematic groupings within a screen of patterned shapes. Vasarely had entered an uncharted zone and was producing some of the most challenging paintings of his career, specifically in the Gestalt and Vega series. In these astonishingly layered paintings, volumes exist on both a factual and illusory level. The artist seems to be proceeding indefatigably and without trepidation through an accelerating stratosphere of painterly space and time, perpetually working against the limitations of formal flatness. He moves both visually and conceptually in order to represent illusion as a function of sensory response to painting.

Gestalt and Vega are Vasarely's most advanced applications of this systematic approach to form and color on canvas. Gestalt offers a shifting architectural modularity and Vega, a system equivocating between biology and geometry—but completely unified in the most exorbitant Baroque sense of composition. Examples from the Gestalt series must necessarily include a triumvirate of masterworks: *Keple-Gestalt* (1968, plate 39), *Izzo-22* (1969), and *Gestalt-Rugó* (1978). In contrast to the matrix formations in the Alphabet Plastique and Folklore Planetaire series, the Gestalt paintings give us something more daring, more permutable, and more defiant in terms of how we perceive—or think we perceive—these solid, yet ethereal, platonic forms.[23] The intense variations of hue in these confounding, yet beautiful hard-edged images elicit a miraculous, uncanny light. They hover more or less symmetrically within uniform spaces, but beyond that, there is little certainty. The crystalline knots, whether in two or three dimensions, twist and turn through ambiguous spatial interstices, leaving us in a state of awe, if not intellectual exhaustion, as we attempt to decipher their infinitely charged, illusory meaning.

The Vega paintings represent another kind of paradox—not angular, but spherical. One of the earliest, a painting done in black-and-white checkerboard squares, appeared in 1957 and was possibly derived from *Arlequin* (1936–42, plate 7), an even earlier fig-

urative painting. The title *Vega* refers to the brightest star in the Lyra constellation, and thus the undulations in the paintings of this series evoke the movement of the star in and out of the sky, depending on the quality of its brightness.[24] From the 1960s onward, the Vegas are decisively painted in color. Contained either by a dot matrix, as in *Fél-Gat* (1967), or a grid matrix, as in *Vega-Nor* (1969, plate 42), a sphere bursts through the center of a polychrome field. Yet nothing changes in the universe of Vega other than the permutation of the spherical forms. These paintings are cool, but emotional. In *Fél-Gomb* (1969/72), two half-spheres at the top and bottom bend toward an invisible horizon, suggesting an imminent protrusion at either end. Another, *Vega-Feck* (1969), holds a different kind of infinity. If anything, the sphere appears more illusory. The shape in the center equivocates, breathing in and out, so that we are uncertain of its form. But words cannot describe colors—as Wittgenstein so accurately stated. They are two separate forms of experience. Color has its own language with respect to form, and this is what these paintings makes clear.

The artist picked up this theme again in his 1974 painting *Vega-Fr*, using a dot matrix and darker hues. The structure is less illusory at first glance, until one looks more closely. There is always deception in Vasarely's paintings. It is only a matter of time before the paradox, the vacillation, the dialectical pulse of the Vega paintings becomes apparent—even in *Einstein-Ker* (1976), in which a great sphere is poised in a spatial cube. Here again we discover that the construction of illusion and the construction of reality are not exactly in opposition to one another. If we are to believe the evidence Vasarely shows us, the universe at either end—be it reality or illusion—is, after all, much the same.

Universal Structures

The phrase "dematerialization of art" was applied to the work of Conceptual artists in the late 1960s. But this was a much too limited category for the plethora of optical possibilities produced and imagined by Victor Vasarely. Whereas Conceptualists focused primarily on the concept or the idea within the system, Vasarely—along with other artists ranging from Agam to Anuszkiewicz, Bridget Riley to Morellet, Cruz-Diez to Tomasello—applied their systematic optical procedures to the task of seeing and to distinguishing the appearance of things from how they actually are. Optical artists were more interested in the visual manifestation of the idea, rather than in the idea itself. They relied more on a pragmatic combination of empirical knowledge and phenomenal reality than on language as a statement of intention.

Although the term *dematerialization* was appropriated by the Conceptualists, it holds significance for the opticalists as well.[25] It applies, for example, to the light waves we perceive in constructing a mental image. Whether our perceptions are derived from actual objects or from electronic pixels, dematerialized phenomena are as much about physics as they are about language, as much about science as about art. The difference between Conceptualists and Vasarely is that the latter naively believed that art could improve the lot of humankind and that the experience of art should be within reach of those outside its professional ranks. The irony is that the concept of dematerialization more accurately describes the work of Vasarely than that of most Conceptualists. He probably would have embraced it if the term had not already been expropriated by the American avant-garde. Vasarely always felt closer to the humanist tradition.

By the early 1970s, Vasarely was as much a known artist as a known commodity—the latter, of course, being the real problem. His reputation and his images had spread beyond the confines of the art world. In 1971, he inaugurated the Vasarely Museum in Gordes, France, shortly after receiving the highly prestigious Chevalier de l'Ordre de la Legion d'Honneur in Paris. Five years later, in 1976, the Vasarely Foundation opened in Aix-en-Provence, the refuge of Paul Cézanne, and a museum was inaugurated in Pécs, the artist's hometown in Hungary. Another opened in 1987 at the Zichy Palace in Budapest.

Nevertheless, not all opinions of Vasarely's art in the 1980s and 1990s were favorable. One art historian (of Hungarian origin) has recently suggested that his optical tricks had become "too transparent" and that what remained after a certain point was "pure, decorative game playing."[26] Such comments do not represent an isolated perspective and are somewhat due to the problems involved in marketing his multiples. Although Vasarely's reputation did not appear to diminish drastically in France, it became clear during the 1970s that his print reproductions and optical illusionist games often failed to connect with his utopian vision. His claim that in the future art would be nothing if not a "common collective treasure"[27] may have been understood in Europe but was taken with a degree of cynicism. In America, the connection between Vasarely's socialist idealism and his art was not understood at all. Vasarely's utopian vision lagged behind the thinking of other artists emerging into prominence at the end of the last century, who were either more metaphysical in their idealism (Joseph Beuys) or consciously skeptical of political change and therefore inclined to reject the possibility of a utopian revival (Gerhard Richter). Vasarely, on the other hand, never really abandoned the Bauhaus principle that art, if applied in the proper way, could transform society and therefore make a better world. As a lifelong pursuit, this enduring belief is much to his credit.

It has been said that although his training came directly from the graphic arts and eventually evolved through painting, Vasarely refused to adhere to a single medium. Apparently, he enjoyed using the term *plasticien* to describe himself as a creative artist. The term comes from the word *plastique,* which in Europe and elsewhere is frequently associated with Modernism and is also used in reference to abstract painting. It refers to that which is pliable, moldable, or transformable. The term *concret,* or "Concrete," is almost never used in America to describe the kind of non-objective painting that evolved from the works of Malevich and Mondrian. But in Europe, and certainly in Central Europe, it is a familiar term used to distinguish what is taken indirectly from the external visual world from what is invented within a given picture plane. Vasarely was, of course, primarily involved in the latter. Some characterize his major contribution as extending what is Concrete into the realm of the optical and kinetic, and thus, replacing stasis with kinesis.

Much of Vasarely's work during the last two decades of his life, when he was living and working outside Paris in Annet-sur-Marne, was devoted to extending his vision into new dematerialized forms. He created algorithmic systems that in many ways parallel the development of the computer. In fact, his early forms from the 1950s and 1960s can be seen as precursors to what artists today take for granted as computer-driven digital imagery. Vasarely made his own visual software in the form of mathematics, referring to the blueprints for his paintings as "programs." And they are indeed programs in the same sense the term is used today in relation to the computer. He also understood that no program can extend beyond the parameters it is given. Vasarely gave art to the computer, and for this he must be remembered.

Vasarely believed that we were witnessing the transformation of egocentric thought to expansive thought, which, from his point of view, was collective in origin.[28] He did not, however, refute the right of individuals to engage their own creativity. One has only to see his paintings—*Dyevat* (1975, plate 46) and *Tekers-MC* (1981, plate 49), for example—to comprehend this. He did not deny the breadth of his own creativity, so why would he limit the imagination of others? Even so, he believed that too much of Modernist art neglected to see its relationship to the society. Vasarely, after all, believed that art should communicate social meaning, that it should function the same way that architecture functions, but not with the same utility. According to him, it is this transmission of meaning that is the hard work of painting. Here, in fact, is where the focus of the creative mind resides: to imbue the signs and symbols that one experiences with universal meaning, to breathe significance into the mundane realities of existence, to see the visual world as a repository of creative potential, and to let the imagination soar beyond the limitations of time.

Notes

1. "The Responsive Eye" was curated by William C. Seitz in collaboration with the City Art Museum of St. Louis, the Seattle Art Museum, the Pasadena Art Museum, and the Baltimore Museum of Art. A catalogue accompanied the exhibition: William C. Seitz, *The Responsive Eye*, exh. cat. (New York: The Museum of Modern Art, 1965).

2. Curiously, the exhibition did not show the work of Venezulan artist Jesús Rafael Soto, who later emerged as one of the principle figures associated with the genre.

3. The criticism of utopian ideals in contemporary art was used as a way of setting Post-Modernism apart from Modernism. See Hal Foster, ed., *The Anti-Aesthetic: Essays on Postmodern Culture* (Port Townsend, Washington: Bay Press, 1983).

4. Michèle-Catherine Vasarely, untitled essay in *Vasarely Inconnu*, exh. cat. (Fécamp, France: Palais Bénédictine, 2001), p. 14.

5. Victor Vasarely quoted in *Vasarely Inconnu*, p. 14.

6. Véronique Wiesinger, "From the Hungarian Countryside to the Global Folklore," in *Vasarely Inconnu*, p. 9.

7. Ibid., p. 10.

8. Perhaps this accounts for his early struggle in Paris to leave graphic design for painting and, finally, a year after his 1944 exhibition at Denise René Gallery, to commit himself further to the exploration of Concrete art.

9. The reference here is to Edward Said's concept of orientalism, in which the objectification of the subject is cast as a racial stereotype. Many would argue that this concept is the beginning of postcolonial studies. See Edward Said, *Orientalism* (New York: Vintage, 1979).

10. Gallerist Denise René was an active supporter of the underground resistance during World War II. Vasarely's socialist ideals, while not in full agreement with the Communists in Hungary, were clearly not aligned with the Nazis. Had Vasarely's political affiliations leaned to the Right, he would never have been given an exhibition at René's gallery. See Michelle Cone, *French Modernisms: Perspectives on Art Before, During and After Vichy* (Cambridge, England, and New York: Cambridge University Press, 2001), p. 158.

11. Michèle-Catherine Vasarely states in her essay in the *Vasarely Inconnu* catalogue that the artist began painting in 1937—seven years before his first major exhibition in Paris at the Denise René Gallery. The exhibition is reputed to have included 150 graphics and drawings—and not one painting. Although he was exploring abstract forms in painting at the time of the exhibition, he had not as yet arrived at his well-known optical style. This would begin to reveal itself in subsequent exhibitions at the Denise René Gallery and elsewhere.

12. Victor Vasarely, *Notes Brutes* (1960), as cited by Michèle-Catherine Vasarely in "Victor Vasarely and the Art of the New Millennium," n.d.

13. *L'Échiquier* (1935) suggests the distorted quadrilaterial later seen in his *Hommage à Malévitch* (1953), which exemplifies the artist's idea of "plastic kineticism" as described in his "Manifeste Jaune" (1955).

14. See the brilliant analysis offered by Marcel Duchamp in his 1957 lecture "The Creative Act," delivered at the American Federation of Arts in Houston, in which he articulates the role of the viewer in completing the meaning of a work of art.

15. Note by Vasarely made at Belle-Isle during the summer of 1947, quoted by Michèle-Catherine Vasarely in "Victor Vasarely," n.d.

16. Concrete art generally refers to the kind of geometric abstract painting and sculpture practiced in Europe after World War II, influenced by the Bauhaus and specifically championed by Max Bill. The term is rarely used in American art and criticism. Instead, the term Constructivism is employed, which tends to be less specific and more related to the Russian avant-garde of the early 1920s. See p. 37 for further discussion of Concrete art. See also George Rickey, *Constructivism: Origins and Evolution* (New York: George Braziller, Inc., 1967).

17. Victor Vasarely, "Manifeste Jaune," as quoted in H. H. Arnason, *History of Modern Art,* 3rd ed. (New York: Harry N. Abrams, Inc.; and Englewood Cliffs, New Jersey: Prentice Hall, 1986), p. 513.

18. Vasarely, "Manifeste Jaune," as cited by Michèle-Catherine Vasarely in "Victor Vasarely," n.d.

19. Apparently the exhibition "Lumière et Mouvement" (1967) was widely praised in Paris and thus became instrumental in propelling the artist's career to new heights.

20. I have paraphrased this directly from Michèle-Catherine Vasarely's essay "Victor Vasarely and the Art of the New Millennium," n.d.

21. The artist Sol LeWitt was hired as a museum guard at MoMA in the mid-1960s. Within a year after "The Responsive Eye" exhibit, he began working on systematic structures using open cubes. By 1967, he was referring to his work as "Conceptual Art" (Sol LeWitt, "Sentences on Conceptual Art," *Artforum,* summer 1967).

22. Victor Vasarely as quoted in *Victor Vasarely* (London: Robert Sandelson, 2003), n.p.

23. To compare the Gestalt paintings with the spatial paradoxes of graphic artist M. C. Escher unfairly limits the aesthetic experience that Vasarely's works are capable of inciting, not only on an optical and kinetic level, but on the level of art.

24. H. W. Janson, *History of Art,* 4th ed. (New York: Harry N. Abrams, Inc.; and Englewood Cliffs, New Jersey: Prentice Hall, 1991), pp. 746–47.

25. Lucy R. Lippard, "The Dematerialization of Art" (with John Chandler) in *Changing: Essays in Art Criticism* (New York: Dutton, 1971), pp. 255–76.

26. From an e-mail conversation with Professor Eva Forgacs at the Art Center College of Design in Pasadena, January 2004.

27. See note 12.

28. Paraphrased from a statement by Vasarely quoted in *Victor Vasarely* (London: Robert Sandelson, 2003), n.p.

Plates

Formation and Influences

Vasarely's interest in graphic design and avant-garde art was stimulated by Sándor Bortnyik, founder of the Mühely Academy in Budapest, a technical art school based on ideas assimilated from the Bauhaus in Weimar. (Although it is questionable whether Bortnyik ever matriculated at the Bauhaus, he was frequently seen in Weimar cafés in conversation with students and occasionally with master-teachers, including László Moholy-Nagy, Josef Albers, Paul Klee, and Herbert Bayer.) Attracted by Bortnyik's philosophy and ideas, Vasarely enrolled at the Mühely in 1929, two years after terminating his medical studies at the University of Budapest. Here the young aspiring artist-designer discovered his talent for illustration as well as a strong fascination for color theory. These interests are revealed in *Études Bauhaus,* four small surviving works from 1929 painted within months of his enrolling at the Mühely. Vasarely's eye for color harmonics, proportion, and planar space and form are clearly evident, as is Bortnyik's insistence that color planes be flat and not imply volume. It would take time for Vasarely to develop his own aesthetic, which placed greater emphasis on spatial illusion, opticality, plasticity, and kineticism.

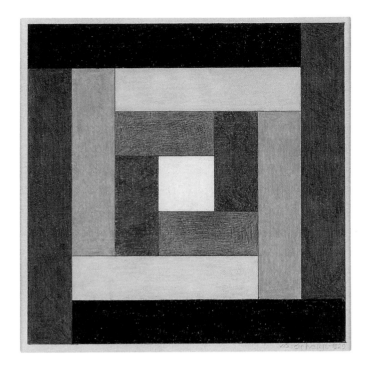
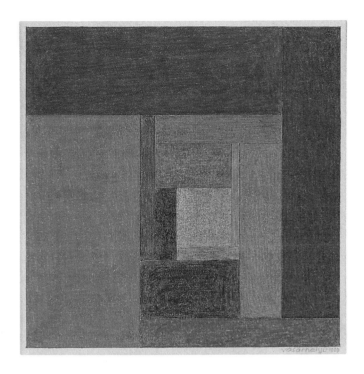
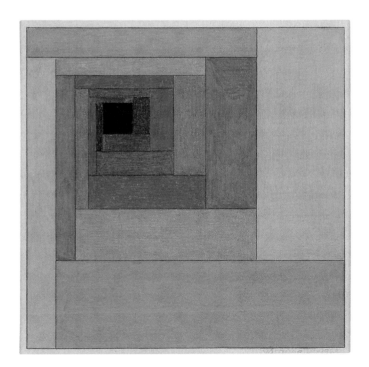
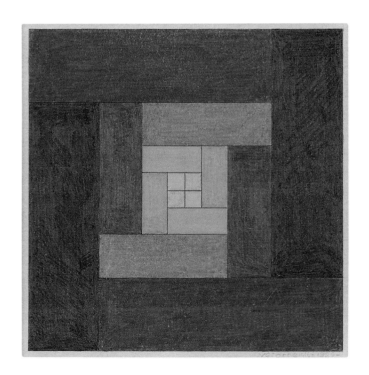

1. *Études Bauhaus (A, B, C,* **and** *D),* 1929, oil on board
9 x 9 in. (23 x 23 cm) each, collection of Michèle-Catherine Vasarely

Paris: Early Years

In 1930 Vasarely moved to Paris, where he began a career in graphic design. Throughout the 1930s and 1940s, he experimented with a considerable breadth of formal and representational ideas. Some of these montages, such as studies involving iconic signs from popular culture executed in subtle gradations of a single color, were quite unusual for the time. Other important motifs from this period include his zebras, checkerboards, and Harlequins, each of which continued to evolve and permute over the following decades.

Vasarely's move away from the graphic image toward painting began around 1943. The following year, he had a major exhibition of his earlier graphic work at the Denise René Gallery, a show that coincided with his early forays into advanced art. By 1945 he was committed to abstract painting, while still referencing motifs from his graphic period.

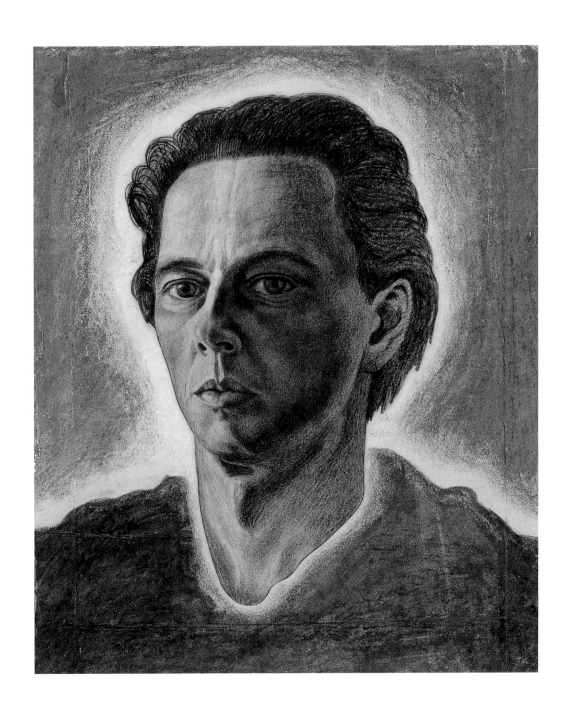

2. *Autoportrait*, 1934, pastel on paper
22 x 14⅛ in. (56 x 36 cm), collection of Michèle-Catherine Vasarely

3. *Étude de Mouvement*, 1935, pencil on paper

19¼ x 20⅞ in. (49 x 53 cm), private collection

4. *Étude Lineaire,* 1935, gouache on board
15 x 22⅞ in. (38 x 58 cm), private collection

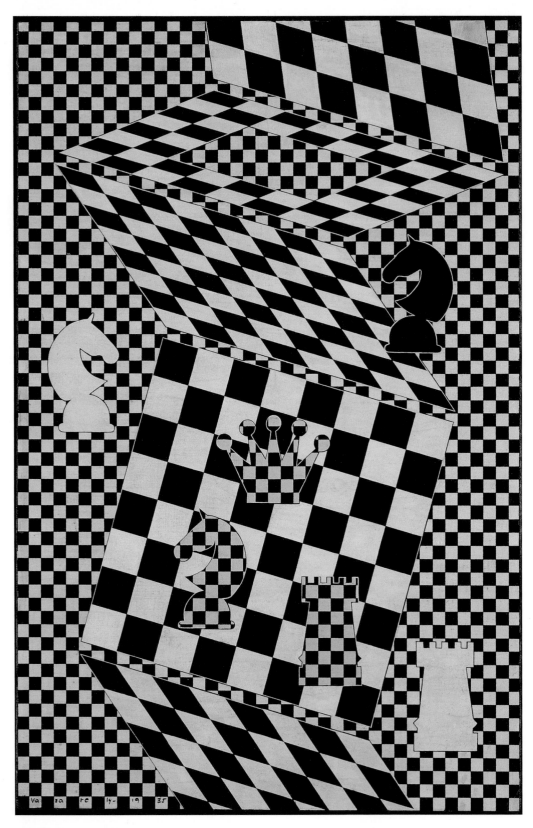

5. *L'Échiquier,* 1935, oil on board
24 x 16⅛ in. (61 x 41 cm), private collection

6. *Étude Lineaire,* 1935, ink on paper
24 x 15¾ in. (61 x 40 cm), collection of Michèle-Catherine Vasarely

7. *Arlequin,* 1936–52, oil on canvas
46⅞ x 30 in. (119 x 76 cm), collection of Michèle-Catherine Vasarely

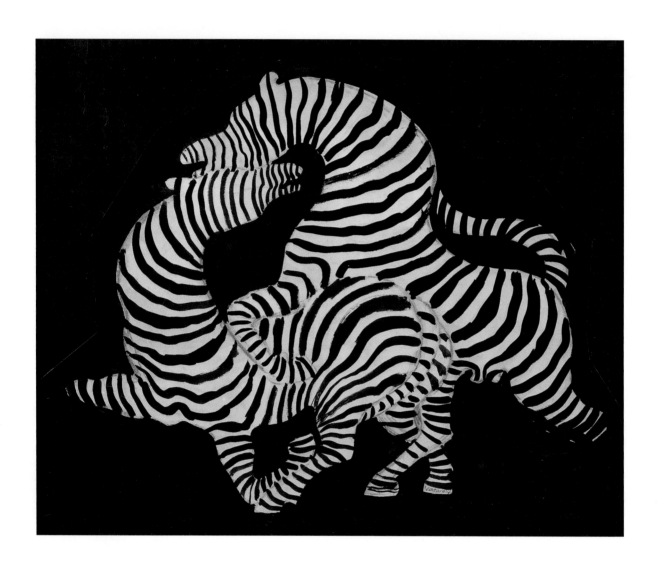

8. *Zèbres*, 1937, ink on board

20½ x 23⅝ in. (52 x 60 cm), private collection

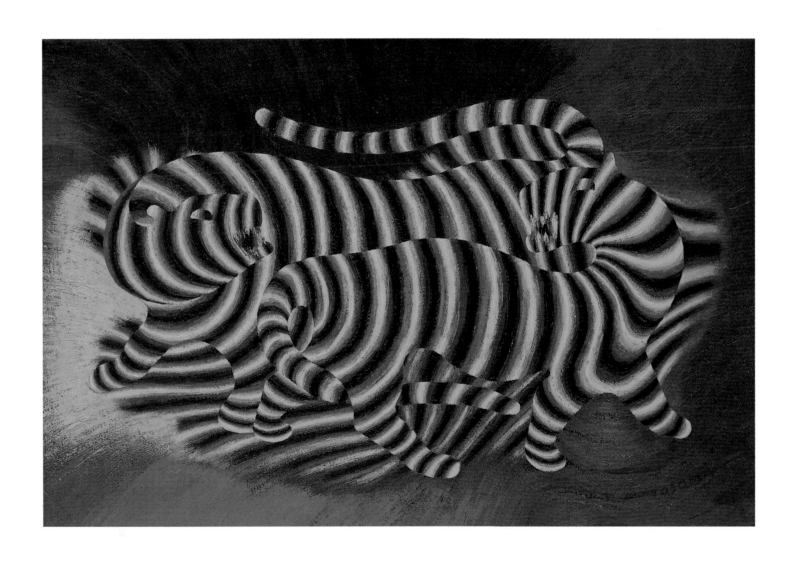

9. *Tigres*, 1938, oil on canvas
32¼ x 48 in. (82 x 122 cm), private collection

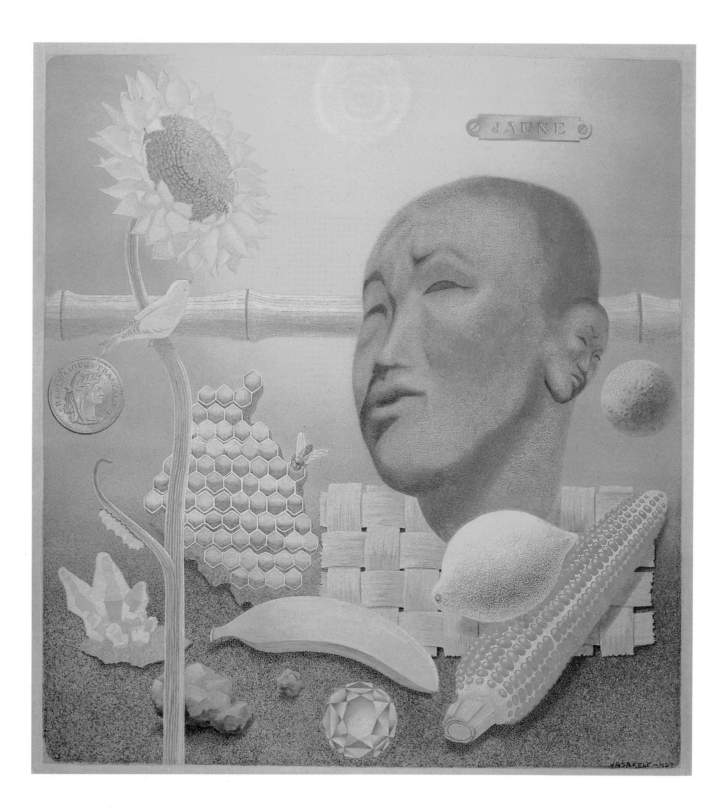

10. *Étude en Jaune,* 1940, oil on board
23⅝ x 21⅝ in. (60 x 55 cm), private collection

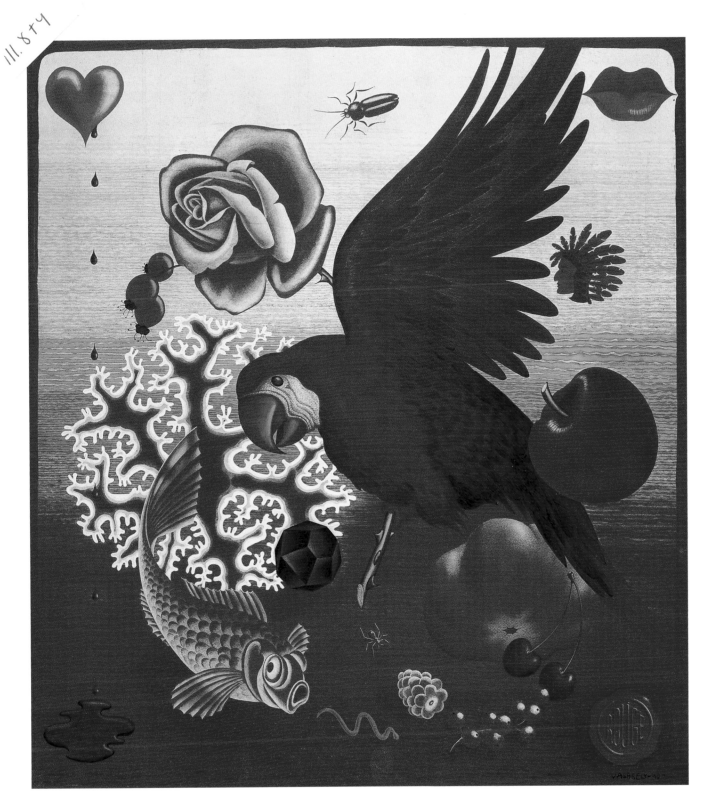

11. *Étude en Rouge,* 1940, oil on board
23⅝ x 21⅝ in. (60 x 55 cm), private collection

12. *Étude en Multicolore,* 1941, oil on board
23⅝ x 21⅝ in. (60 x 55 cm), private collection

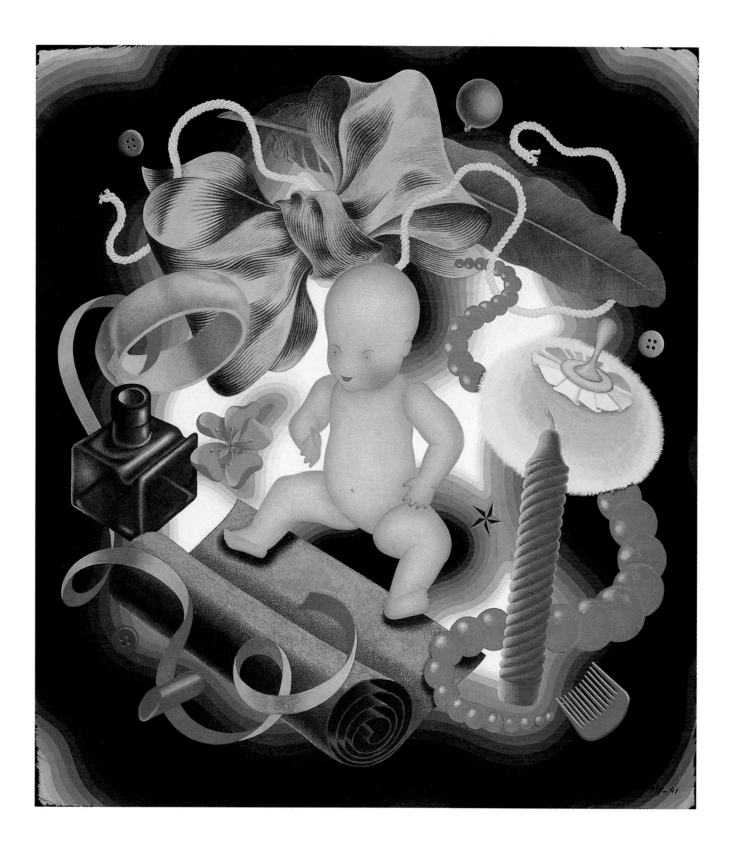

13. *Le Cirque,* 1942, oil on board
28¾ x 26 in. (72 x 66 cm), collection of Michèle-Catherine Vasarely

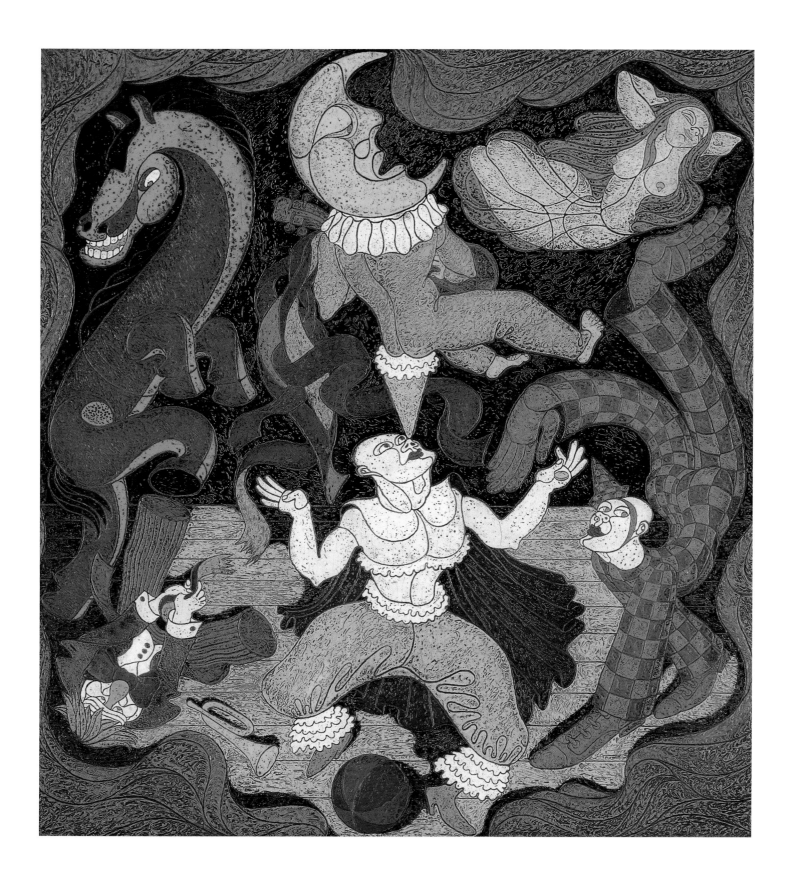

14. *La Cuisine Jaune à Cocherel,* 1946, oil on wood
28⅜ x 35⅞ in. (72 x 91 cm), collection of Michèle-Catherine Vasarely

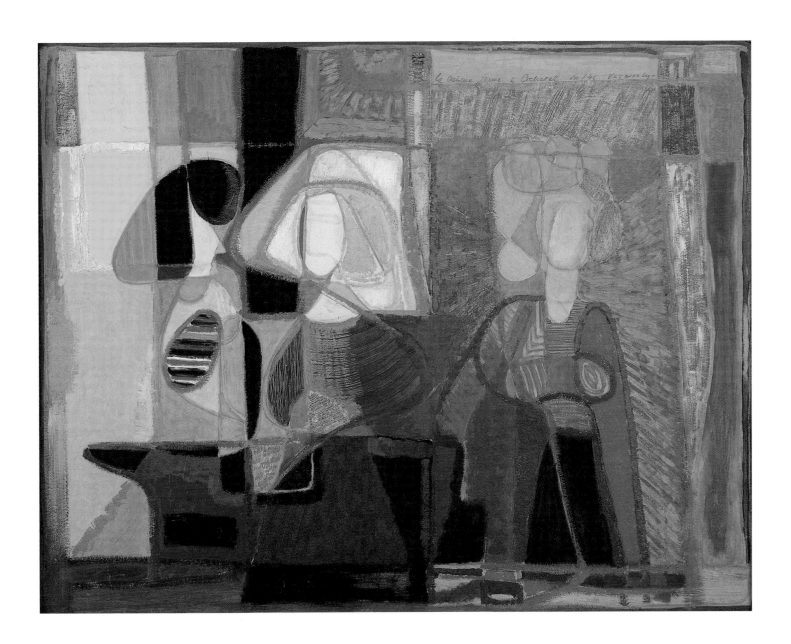

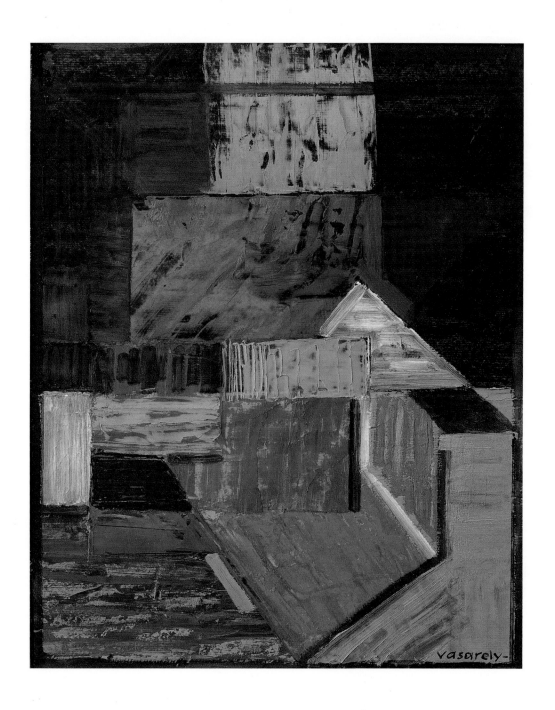

15. *La Maison,* 1946, oil on board

12½ x 11⅜ in. (32 x 29 cm), collection of Michèle-Catherine Vasarely

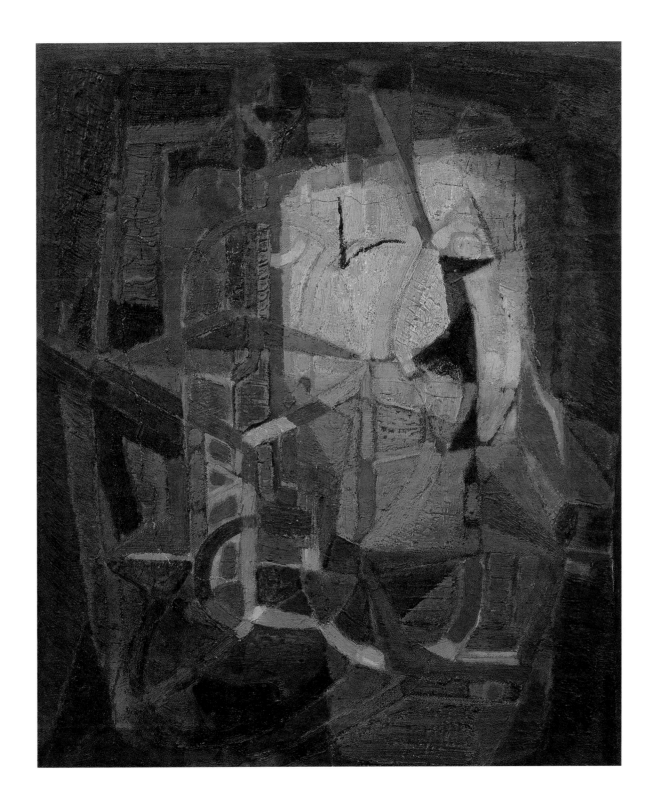

16. *Artiste Devant Sa Toile*, 1947, oil on canvas
18⅛ x 15 in. (46 x 38 cm), private collection

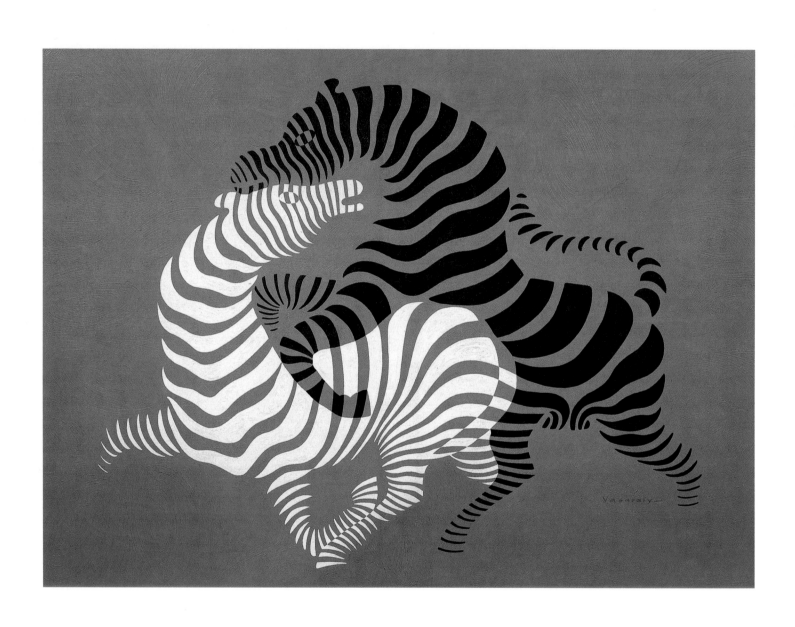

17. *Mi-Zèbre*, 1948–64, oil on canvas
36¼ x 45⅝ in. (92 x 116 cm), private collection

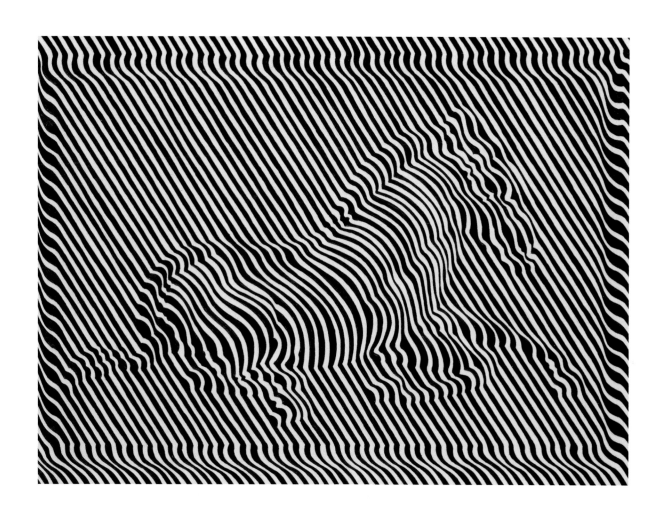

18. *Zèbre,* 1950, gouache on board
7⅞ x 14⅛ in. (20 x 36 cm), private collection

Transitions

Some of Vasarely's most complex abstract ideas evolved between 1947 and 1950 in three different, though related, serial motifs referred to as the Belle-Isle, Denfert-Rochereau, and Gordes-Crystal periods. A new stage of abstract thinking becomes apparent in each, in his transformation of representational images taken from the external visual world into a kind of abstract semiotics.

Vasarely began to spend summer vacations in Belle-Isle, an island off the coast of Brittany in France, during the 1930s. Here, his experience of nature—the rocks, shells, waves, and clouds he observed while walking along the shore—fascinated him. These ongoing observations overlapped with many he made during roughly the same period of cracked tiles in the Denfert-Rochereau metro station, which he frequently passed through on his way to Paris. The Gordes-Crystal series—named for a town near Provence, where Vasarely also vacationed—gave greater subtlety and clarity to his thinking as he began, in 1947, to conjugate everyday visual phenomena into abstract geometric or "crystal" forms. Vasarely continued to explore these motifs in the 1950s, while gradually moving toward the sole use of black and white—what the French poet Jacques Prévert called Vasarely's "*imaginoires*" (a combination of *imaginaire* and *noir*).

Vasarely's response during these years to the work of Kazimir Malevich, particularly the Russian Supremacist's painting of a black square, was also significant in the Hungarian artist's movement toward abstract painting. *Hommage à Malévitch* (1953), Vasarely's optical interpretation of the Russian artist's painting, was the inspiration behind his *alphabet plastique*—a grid-based system that established modular relationships among diverse forms and colors.

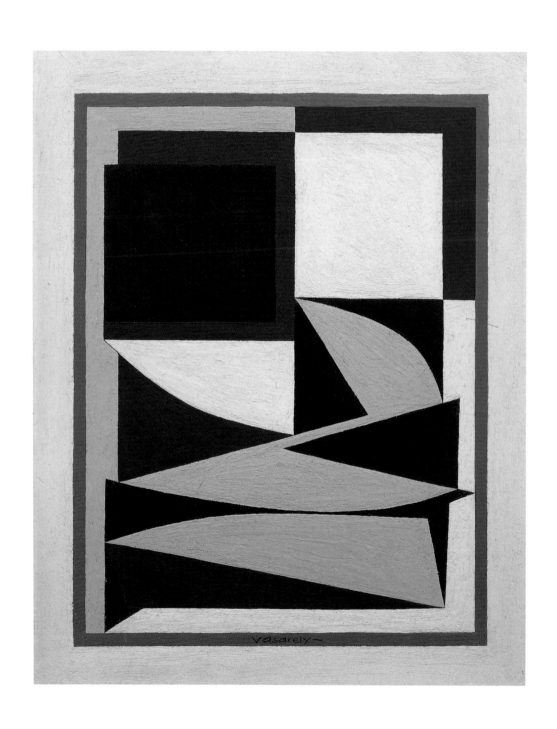

19. *Ézinor,* 1949, oil on board
15 x 11⅞ in. (38 x 30 cm), private collection

20. *Mar Caribe,* 1950, oil on board
18⅞ x 15¾ in. (48 x 40 cm), private collection

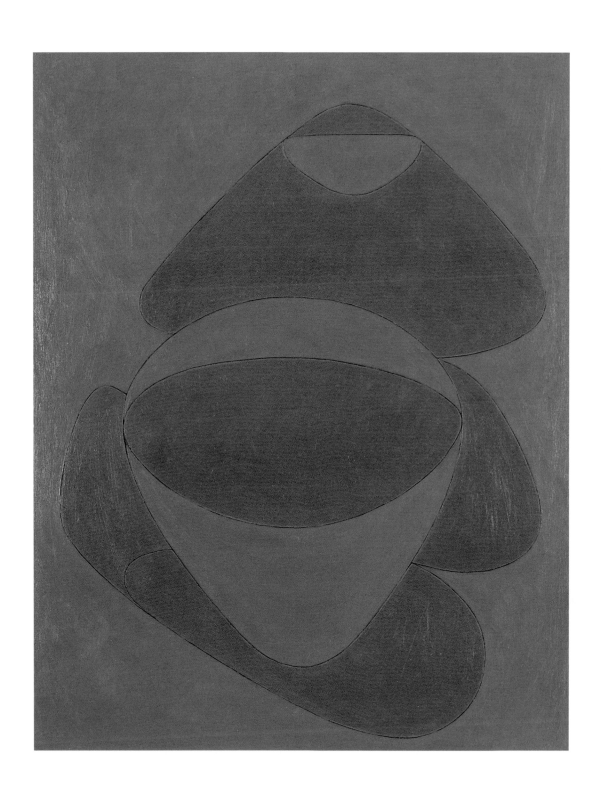

21. *Kandahar,* 1950–52, oil on pressed board

39¼ x 42⅝ in. (100 x 108.3 cm), Solomon R. Guggenheim Museum, New York (54.1396)

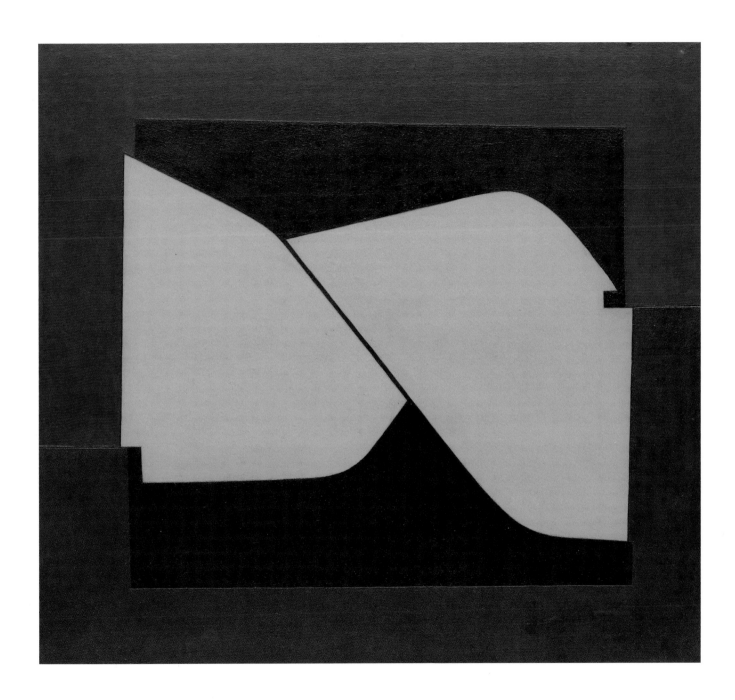

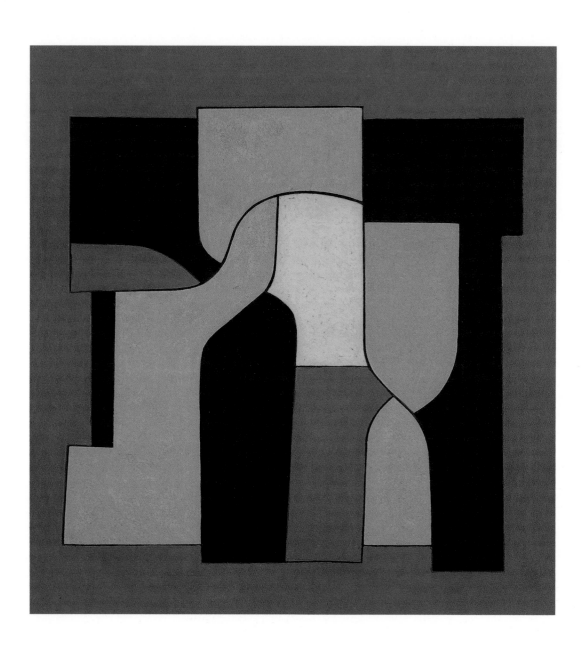

22. *Maranon,* 1951, oil on board
13 x 12¼ in. (33 x 31 cm), private collection

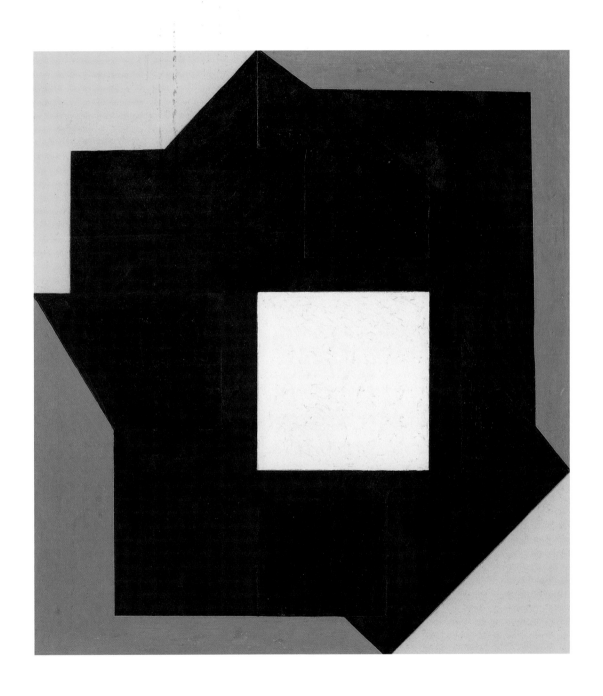

23. *Senanque-2,* 1951, oil on board
13⅜ x 12¼ in. (34 x 31 cm), private collection

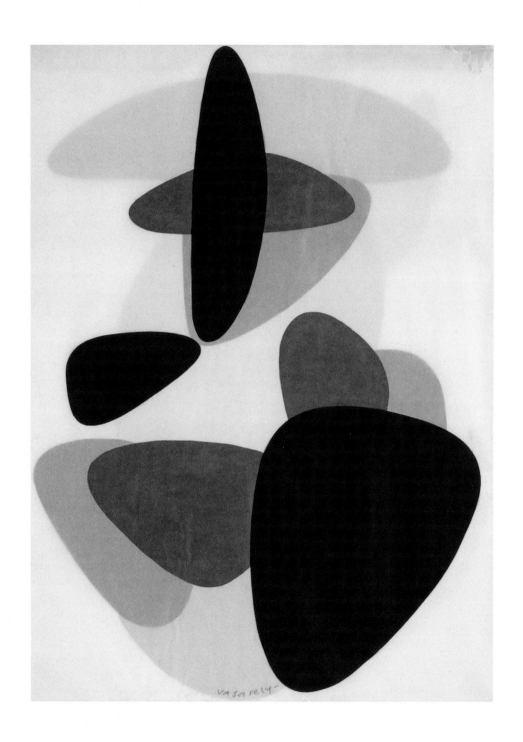

24. *Banghor*, 1951, ink on layered parchment
25½ x 17¾ in. (65 x 45 cm), collection of Michèle-Catherine Vasarely

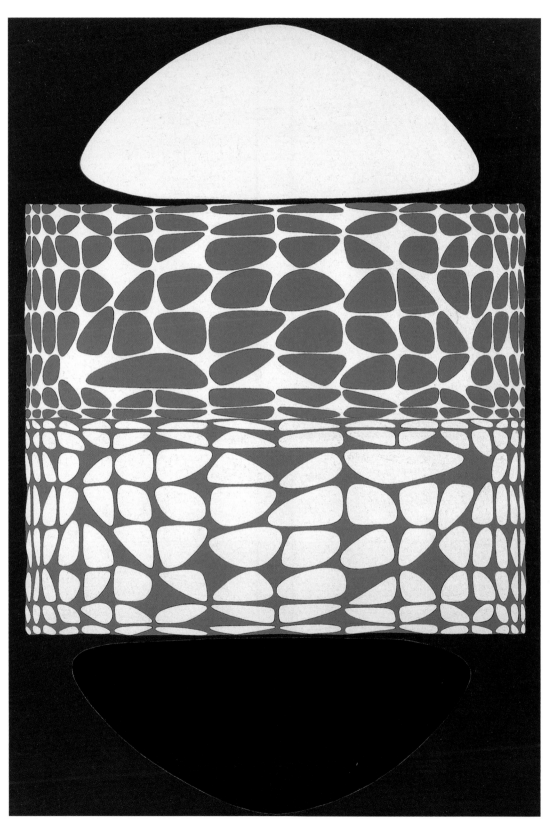

25. *Méandres Belle-Isle,* 1951, oil on canvas
59 x 40⅛ in. (150 x 102 cm), private collection

26. *Mindanao,* 1952–55, oil on canvas
64 x 51⅛ in. (162 x 130 cm), gift of Seymour H. Knox, 1958, Albright-Knox Art Gallery, Buffalo (K1958:45)

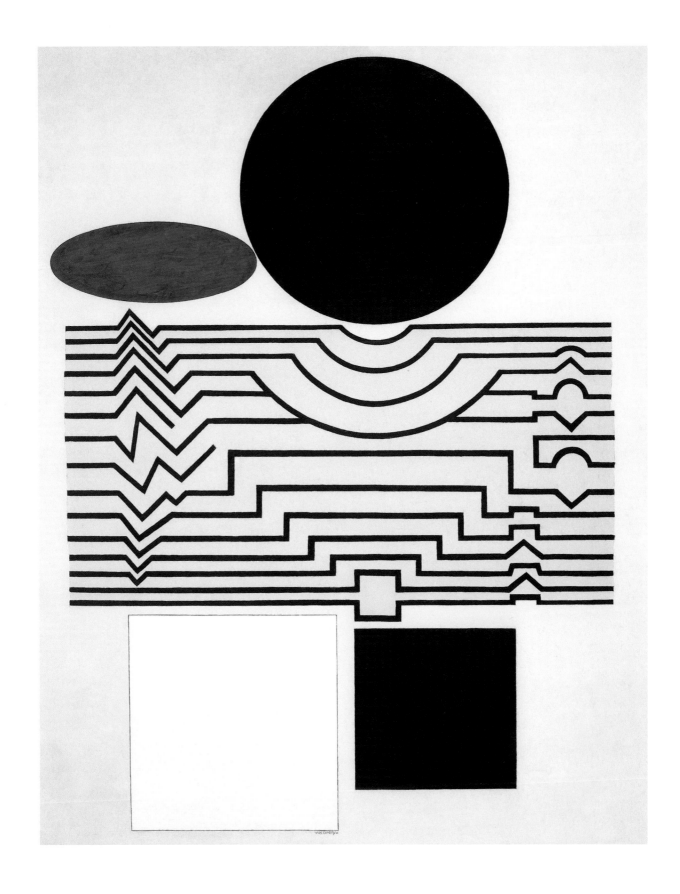

27. *Yvaral,* 1956–65, acrylic on canvas
82⅝ x 78¾ in. (210 x 200 cm), collection of Michèle-Catherine Vasarely

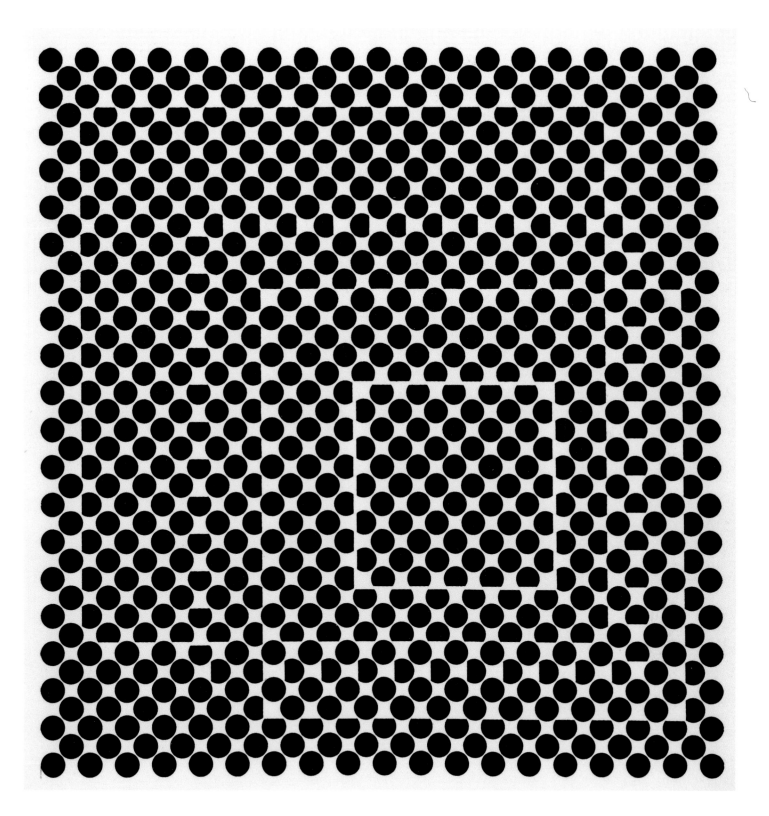

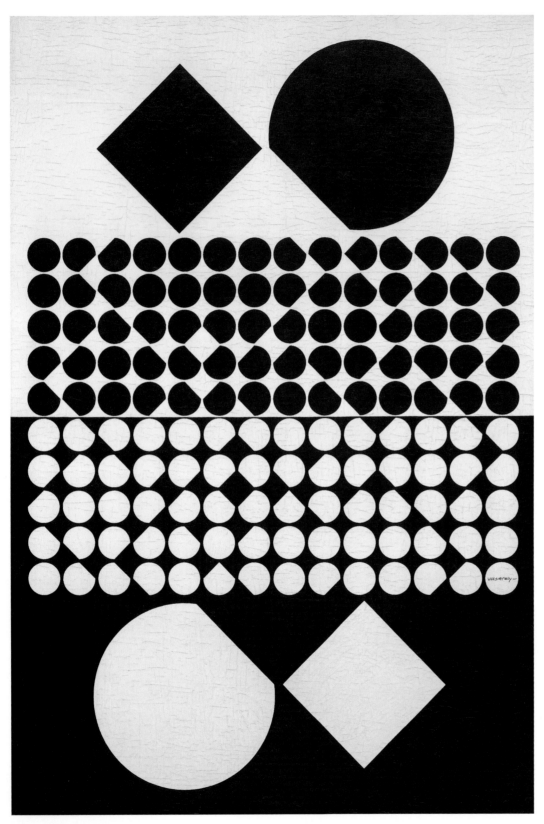

28. *Cassiopée-II,* 1958, acrylic on canvas
76¾ x 51⅛ in. (195 x 130 cm), private collection

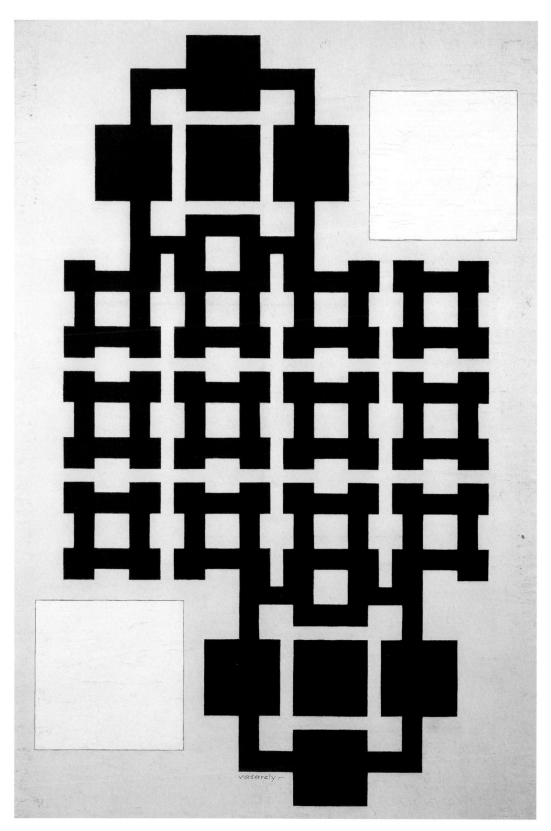

29. *Binaire*, 1960, acrylic on canvas
76¾ x 51⅛ in. (195 x 130 cm), private collection

30. *Riu-Kiu-C,* 1960, acrylic on canvas
45¼ x 45¼ in. (115 x 115 cm), private collection

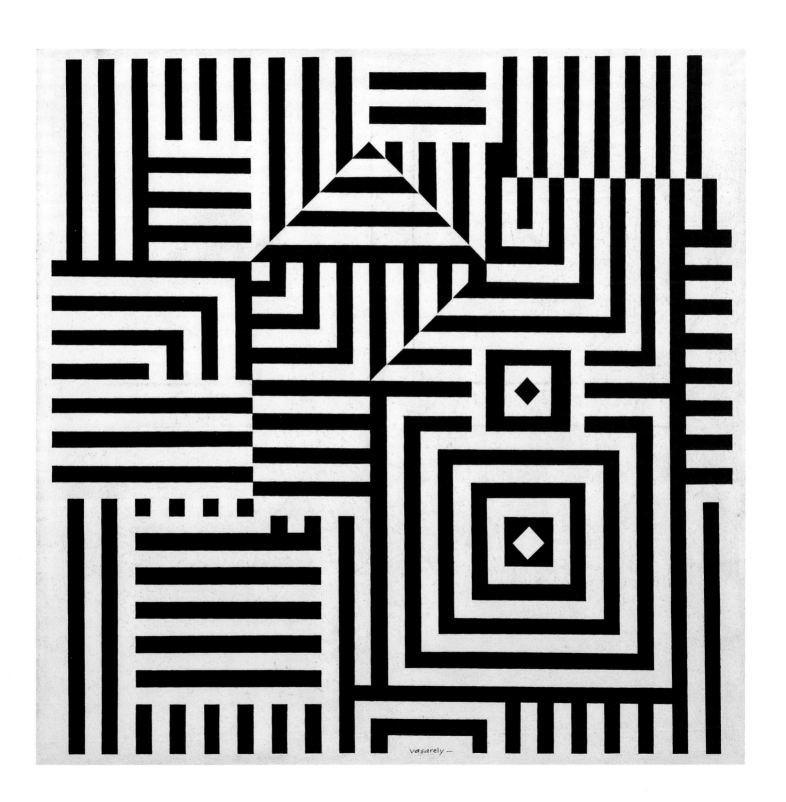

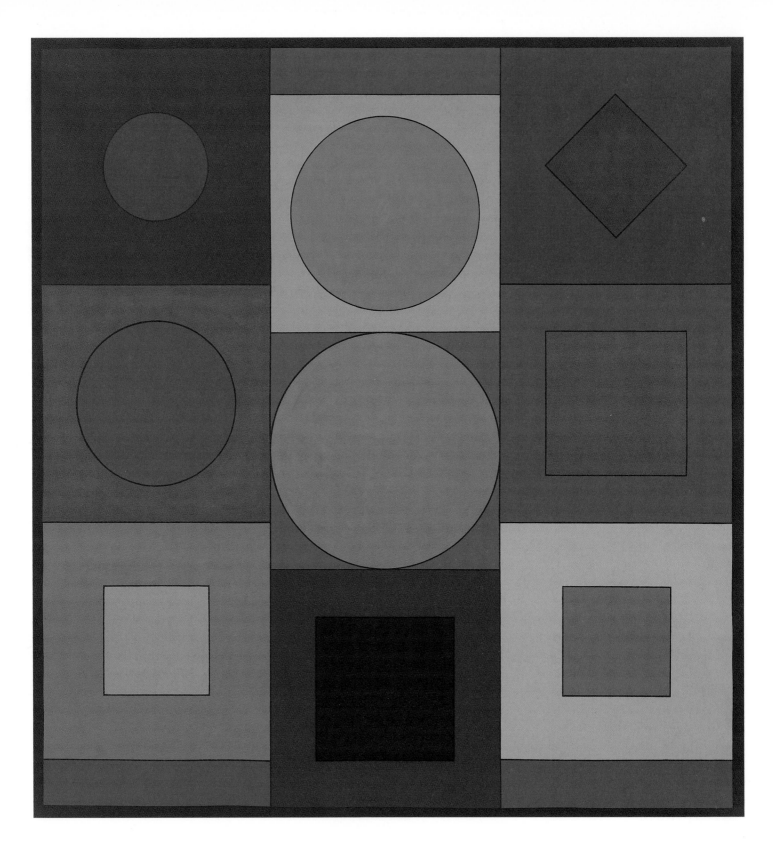

31. *Alphabet VB*, 1960, acrylic on canvas
63 x 59 in. (160 x 150 cm), private collection

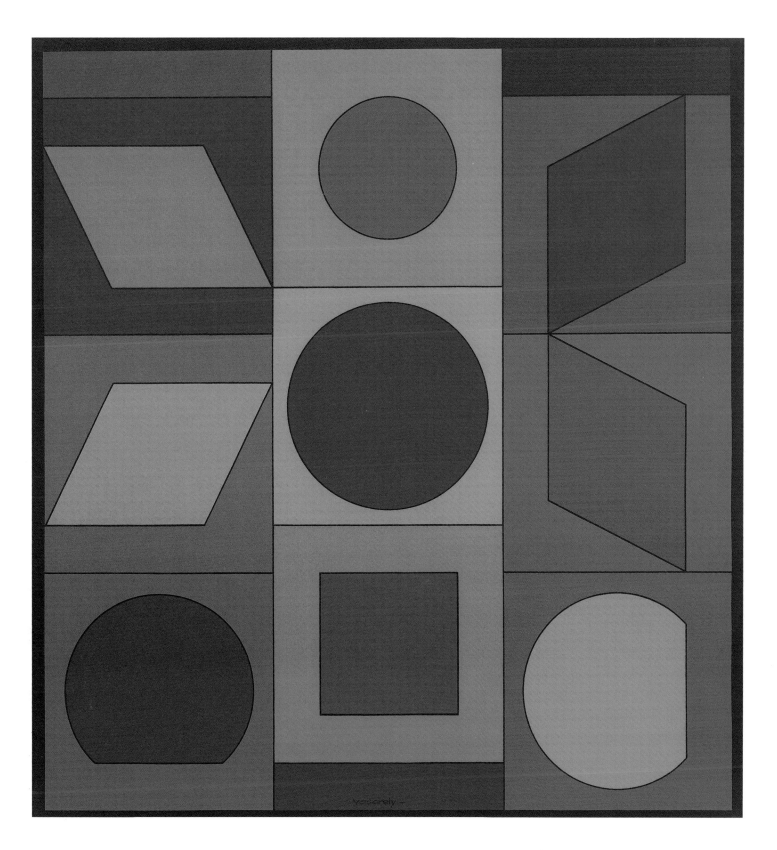

32. *Alphabet VR*, 1960, acrylic on canvas
63 x 59 in. (160 x 150 cm), private collection

33. *Lux-Novae,* 1962, acrylic on canvas
74¾ x 51⅛ in. (190 x 130 cm), private collection

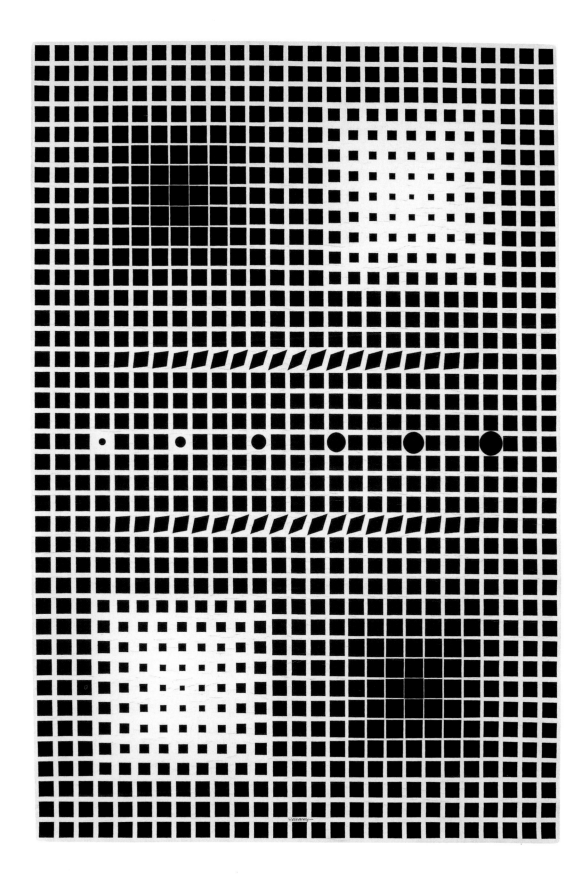

34. *Our-MC,* 1964, acrylic on board

13 x 12¼ in. (33 x 31 cm), collection of Michèle-Catherine Vasarely

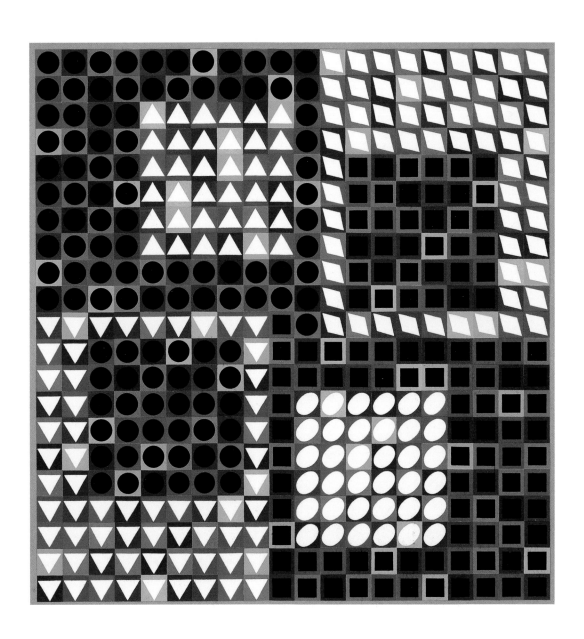

35. *Naissance,* 1964, acrylic on canvas
70 x 60⅝ in. (178 x 154 cm), private collection

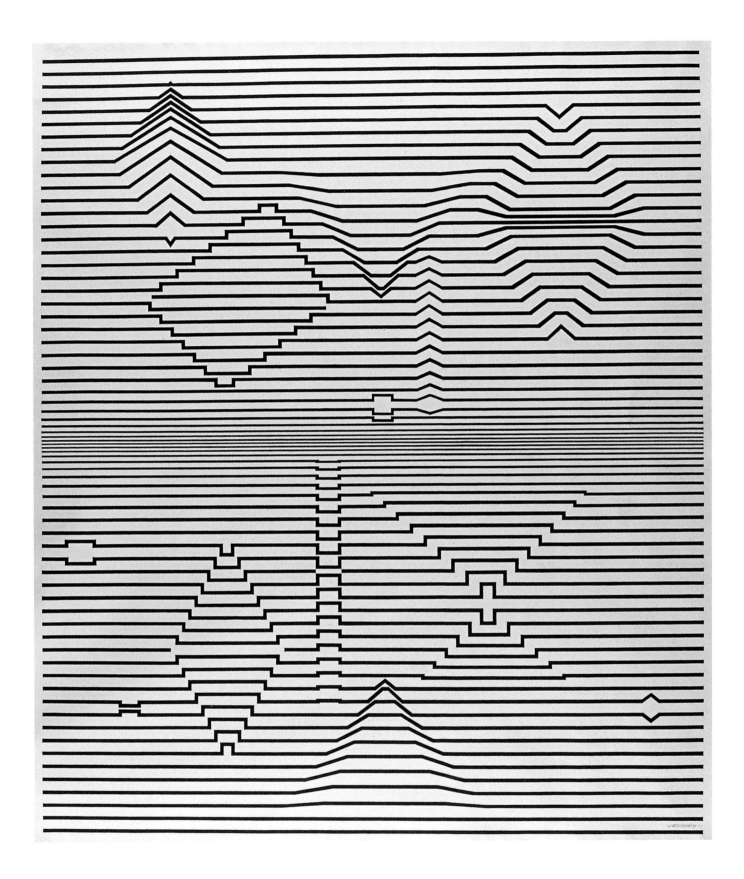

Innovator of Optical Art

By 1960, Vasarely had made a further breakthrough in his concrete vision: a new method of abstraction based on the use of geometric and elliptical forms. This signaled the full realization of his *alphabet plastique* and, eventually, of his theory of *folklore planetaire*—the latter being a variation of the former. These forms function as mutable signs, as in *Our-MC* (1964), and create, when placed together, the effect of optical movement based on complex interactions among complementary colors. In the *folklore planetaire* series, Vasarely began a more involved mathematical exploration of algorithms, using optical color devices and the modularity of form, as a means of representing kinetic units of time. While these paintings appear systematic, the artist refused to limit the meaning of his work to its technical aspect alone. He wanted to liberate his method of working from any kind of formal predictability. Although Vasarely did strive for "identical production" in his work, he saw in his methods the possibility for a new kind of authenticity. In his Vega and Gestalt series, for example, we begin to see a kind of surface billowing, an undulating illusionistic space that breaks definitively from his earlier Bauhaus training. In his work of the late 1960s and 1970s, Vasarely became increasingly interested in these kinetic effects—"the aggressive elements of a picture," according to art historian Werner Spies, that "prevent a static comprehension."

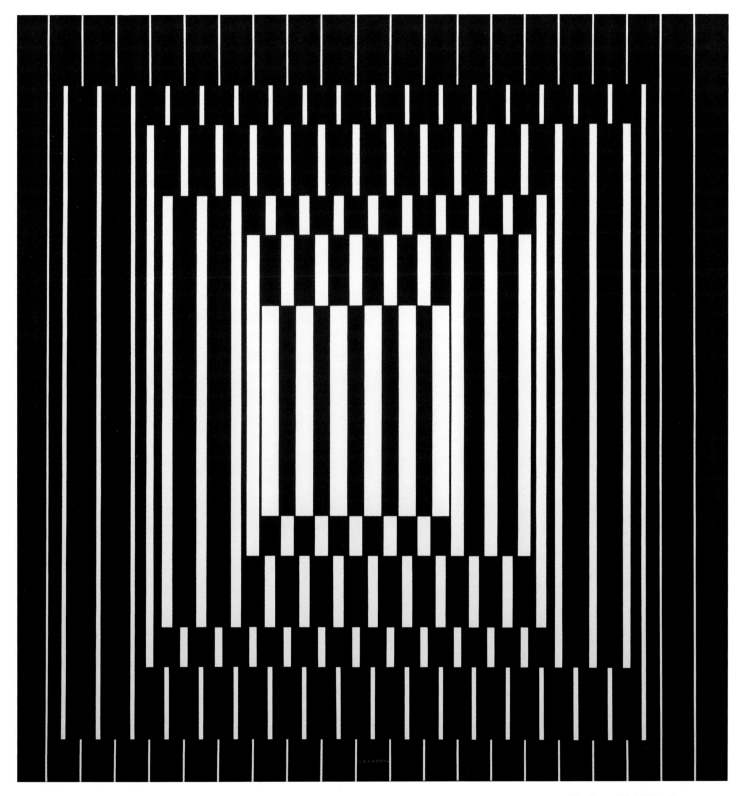

36. *Bora III*, 1964, oil on canvas
58¾ x 55½ in. (149.2 x 141 cm), gift of Seymour H. Knox, 1966, Albright-Knox Art Gallery, Buffalo (K1966:2)

37. *Majus-MC,* 1967, acrylic on board
20½ x 20½ in. (52 x 52 cm), private collection

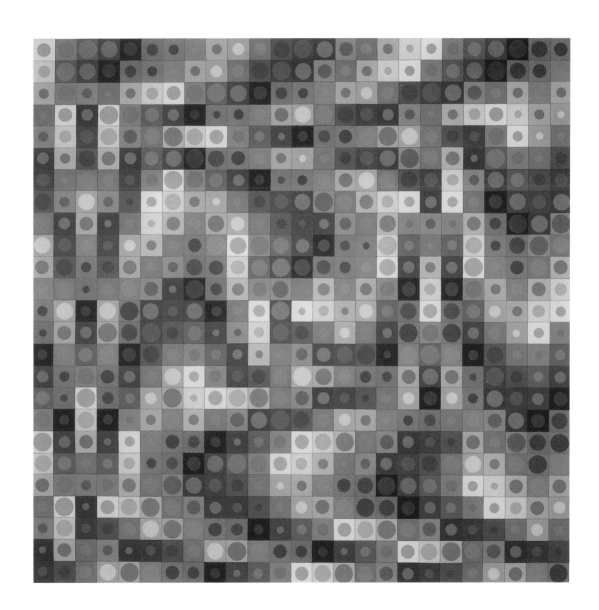

38. *Yvalla,* 1968, acrylic on canvas
99⅝ x 83⅞ in. (253 x 213 cm), private collection

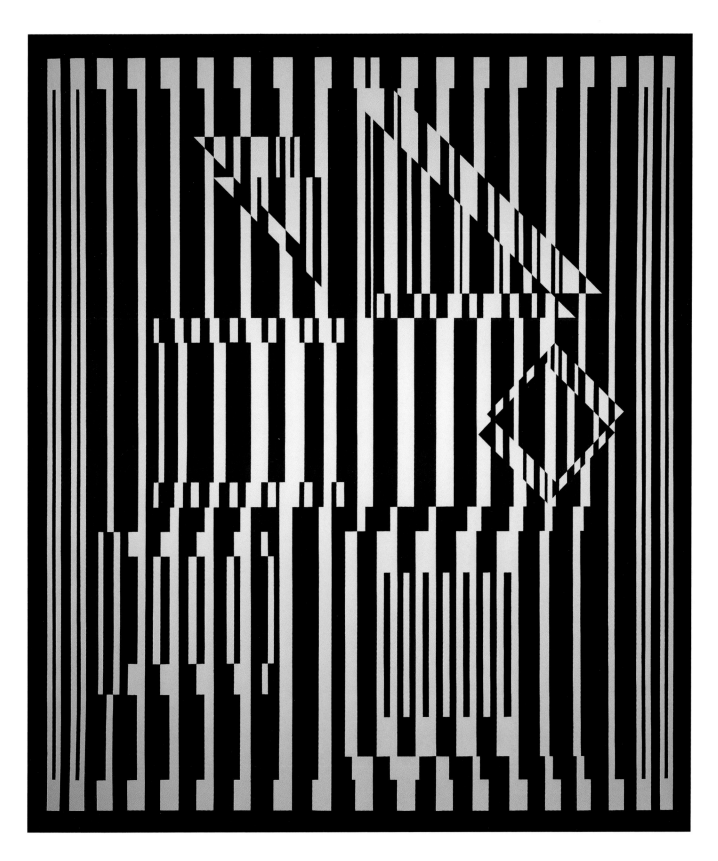

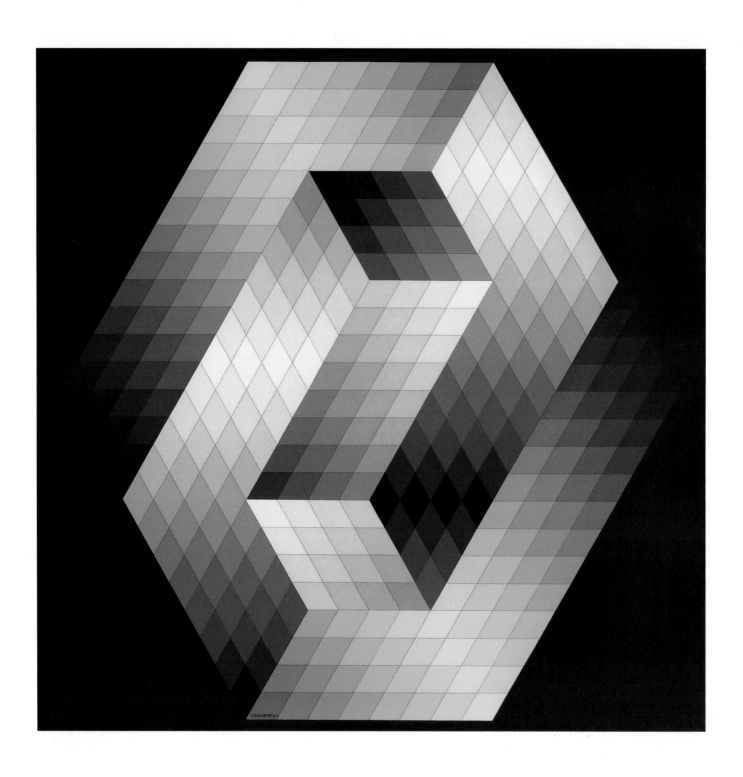

39. *Keple-Gestalt,* 1968, acrylic on canvas
63 x 63 in. (160 x 160 cm), private collection

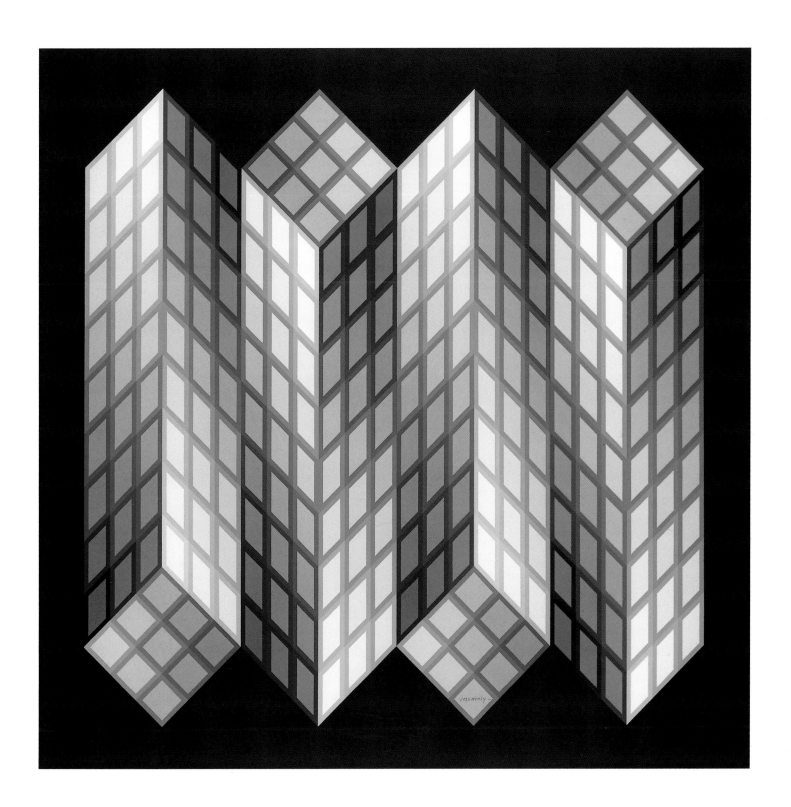

40. *Torony-Nagy,* 1969, acrylic on canvas
78¾ x 78¾ in. (200 x 200 cm), private collection

41. *Orion Gris,* 1969, acrylic on canvas
78¾ x 78¾ in. (200 x 200 cm), private collection

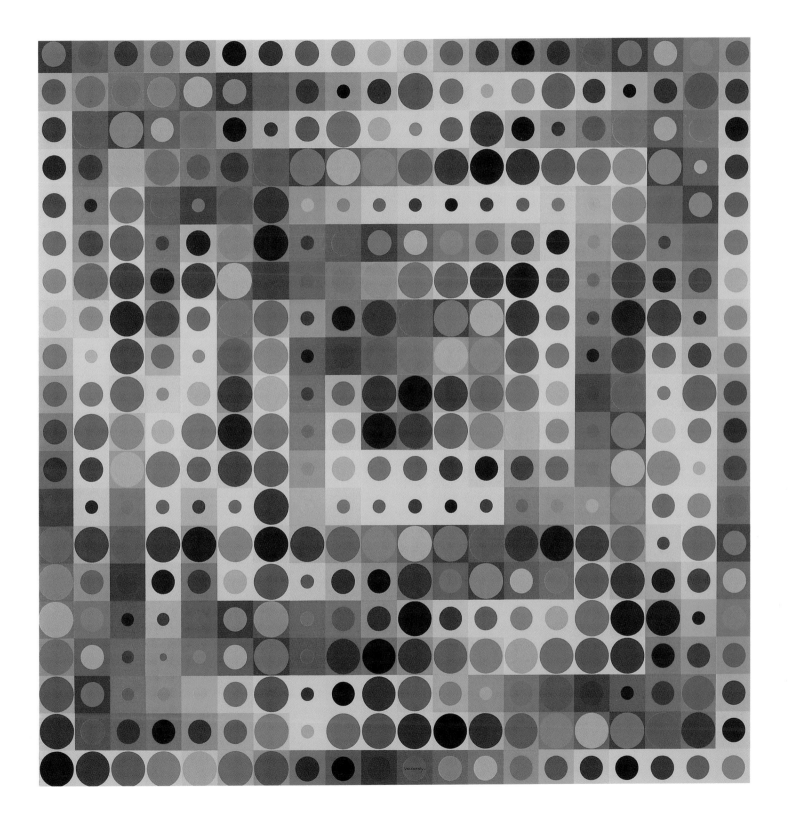

42. *Vega-Nor,* 1969, acrylic on canvas
78¾ x 78¾ in. (200 x 200 cm), gift of Seymour H. Knox, 1969, Albright-Knox Art Gallery, Buffalo (K1969:29)

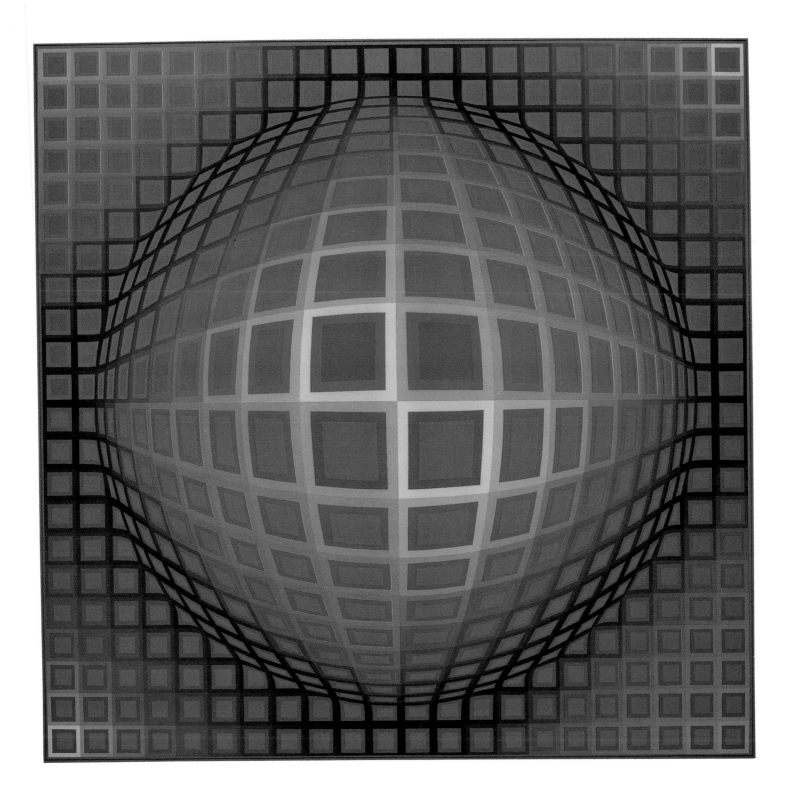

43. *Vega-Lep,* 1970, acrylic on canvas
59 x 59 in. (150 x 150 cm), private collection

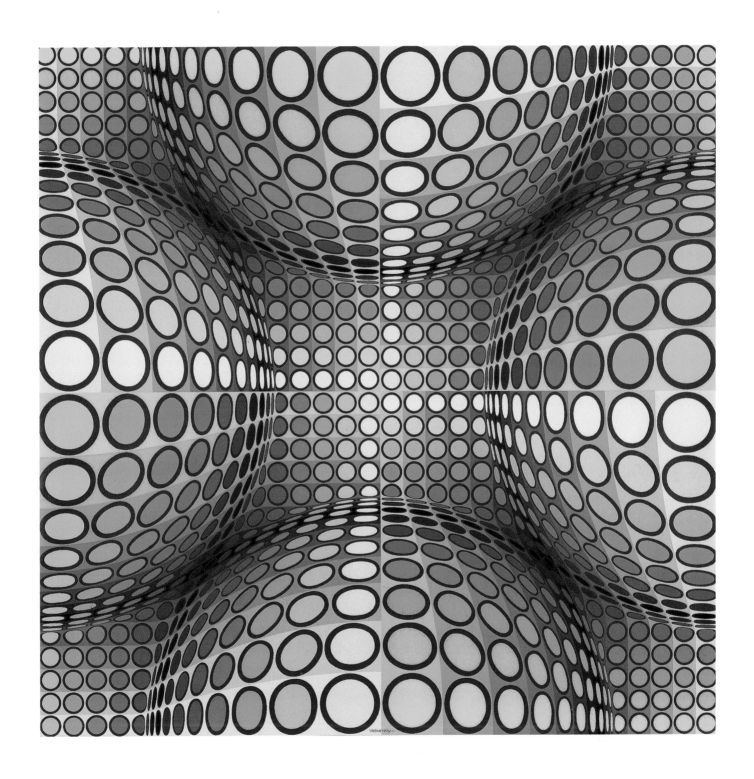

44. *Vega-Miroir,* 1974, acrylic on canvas
55 ½ x 55 ½ in. (141 x 141 cm), private collection

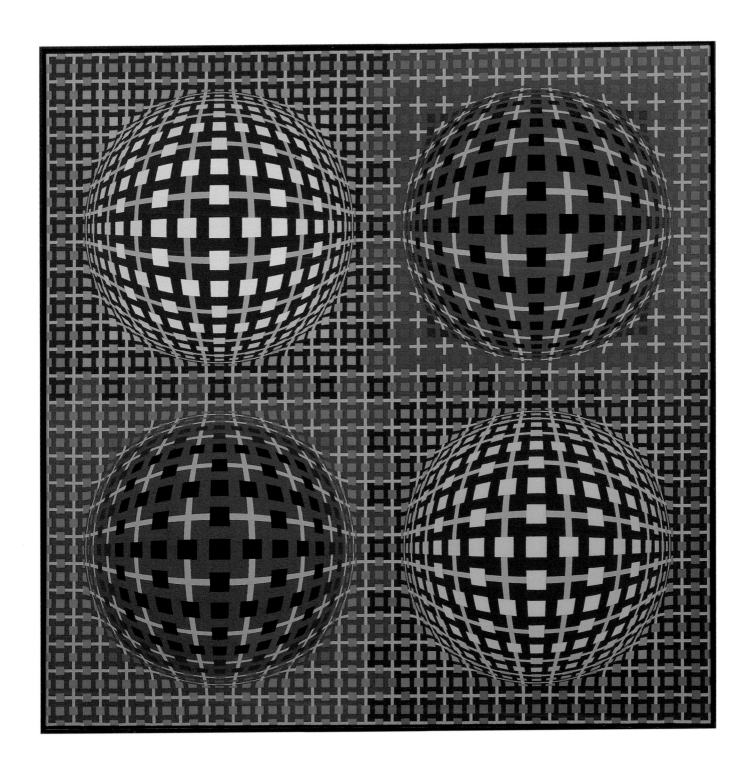

Universal Structures

Vasarely's works from the late 1970s and 1980s are further attempts to break out of the predictability of the system. To achieve unexpected results, he combined mathematical drawings—or "programs," as he called them—made earlier in his career (see pp. 116–18), using them as blueprints, so to speak, for the highly structured compositions of his paintings. This is the period when his digital eye begins to take hold, when he begins to envision the future of art in forms other than just painting. Vasarely was fully aware of the research being done in advanced communications technology, and he saw his work as having implications that went far beyond the Modernist age. Paintings such as *Galaxie* (1979, plate 48) and *Tekers-MC* (1981, plate 49), done when the artist was in his seventies, reveal some of the breadth of his exploration. Cosmic in their suggestion of infinity, these works retain the same vigor they had when they were first painted—the vigor of an artist committed to realizing his vision of art as key to the technological future of humankind.

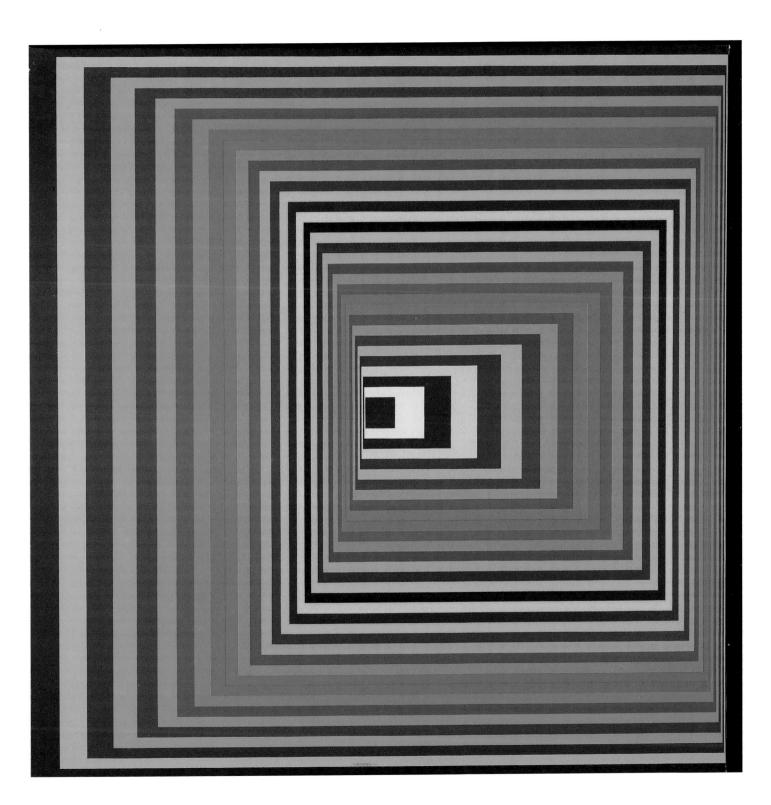

45. *Vonal-Stri,* 1975, acrylic on canvas
78¾ x 78¾ in. (200 x 200 cm), private collection

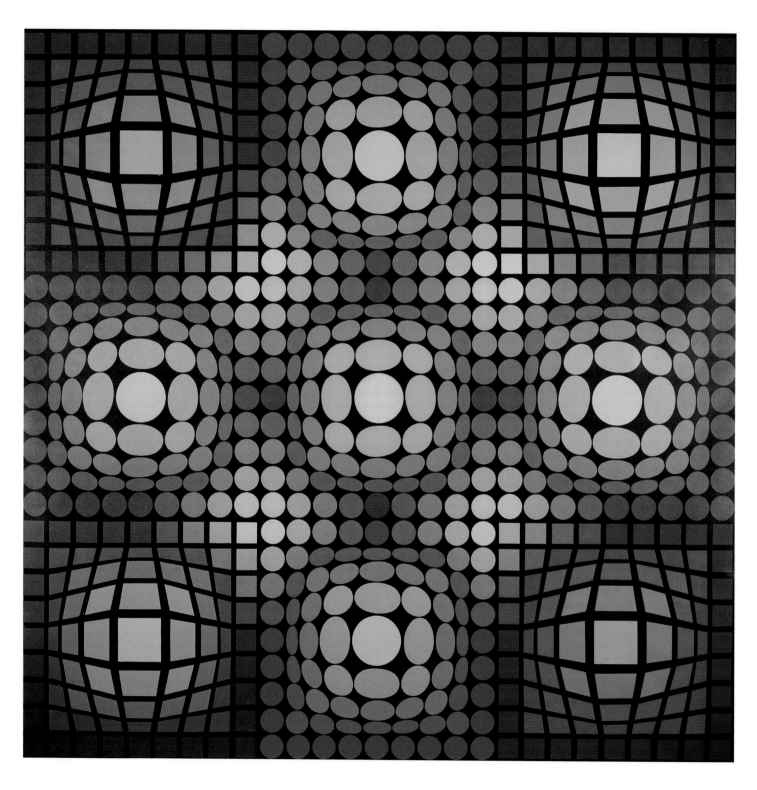

46. *Dyevat,* 1975, acrylic on canvas
78¾ x 78¾ in. (200 x 200 cm), private collection

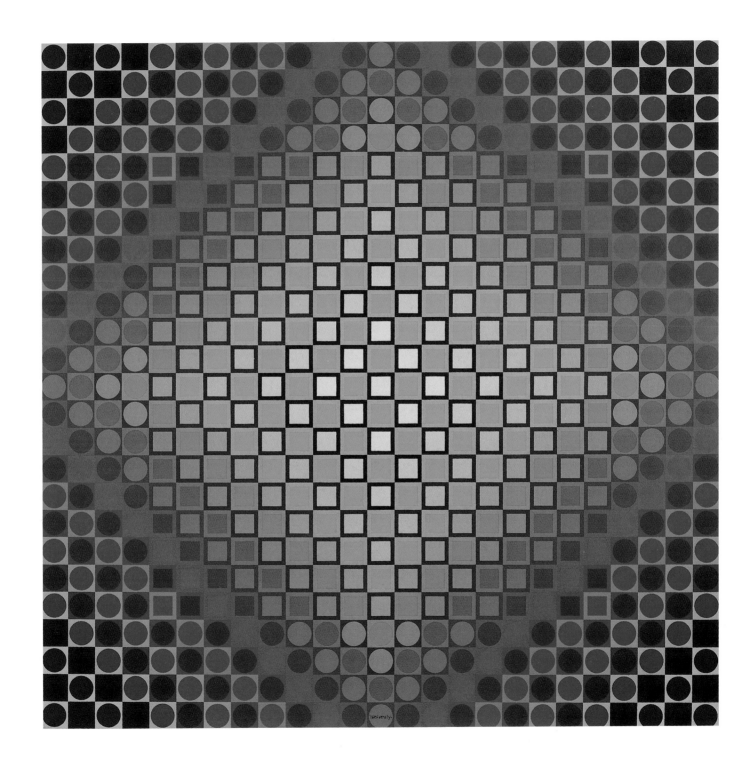

47. *Boglar-Ter,* 1978, acrylic on canvas
63 x 63 in. (160 x 160 cm), private collection

48. *Galaxie,* 1979, acrylic on canvas
70⅞ x 70⅞ in. (180 x 180 cm), private collection

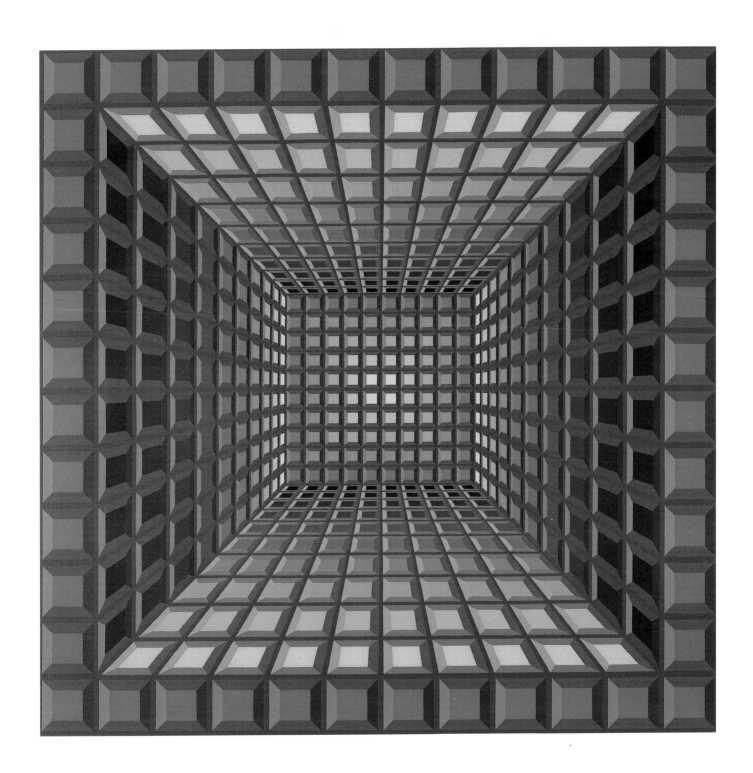

49. *Tekers-MC,* 1981, acrylic on canvas
92½ x 79⅛ in. (235 x 201 cm), collection of Michèle-Catherine Vasarely

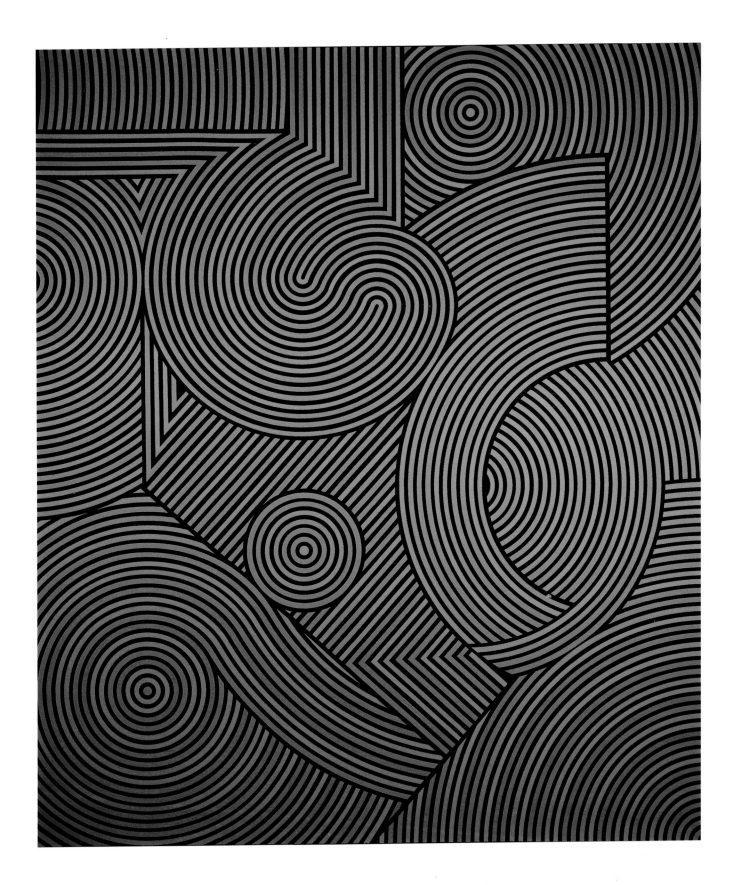

Starting Points

By the time Vasarely invented his Global Folklore concept in the mid-1950s, he was utilizing scale paper to make preliminary drawings he called *programmations* (programs). He described these drawings, a selection of which are reproduced on this and the following two pages, as "starting-point prototypes."

As Vasarely explained to the French art critic Jean-Louis Ferrier, he developed a color system involving "six scales, each with twelve or thirteen nuances, ranging from light to dark, [to which he] added colored blacks." He later made serigraphic prints of these color permutations and continually invented new linear forms and shapes to which he would apply the colors. Vasarely considered these colors his alphabet. Because his system had become quite complex, he would work out color schemes on programs before embarking on a new series of paintings. Initially, Vasarely himself rendered the programs he devised as paintings, but beginning around 1965, he enlisted the help of assistants. Multiples and print editions based on Vasarely's programs were all done by assistants.

Though his use of the term *program* and the fact that he thought of his work in terms of algorithms strongly suggest that he had conceived of many basic computer terms before the technology became available, Vasarely's proto-computer language was, of course, more conceptual than actual.

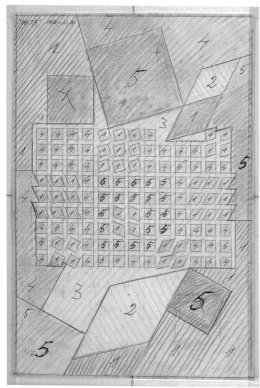

Oeta II, NB, 1956 (A)

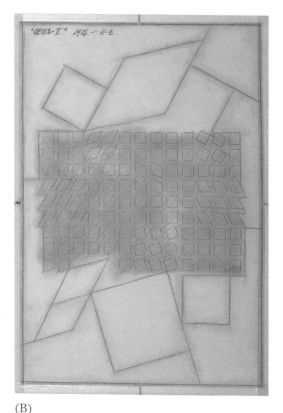

(B)

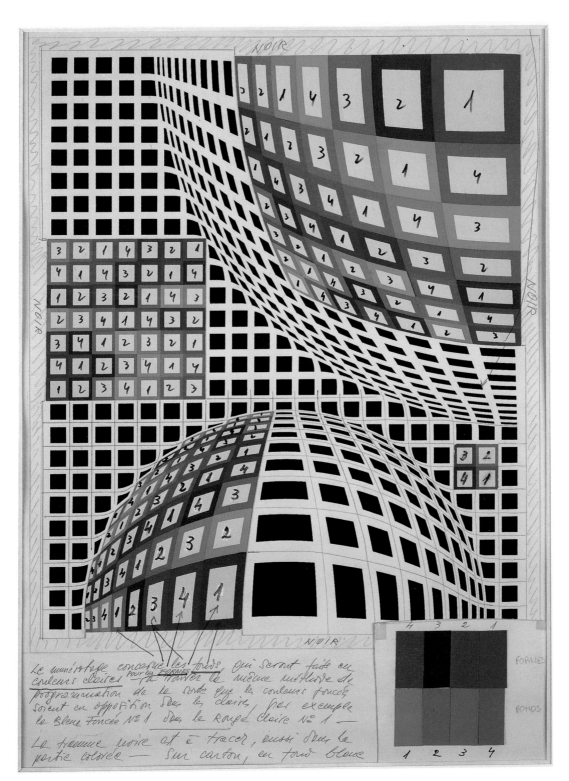

Untitled, ca. 1978

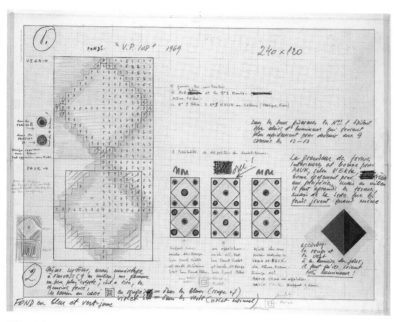

V.P. 108, 1969

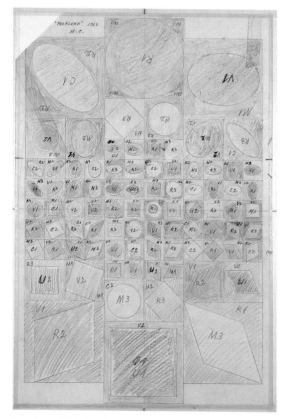

Folklore, MC, 1963

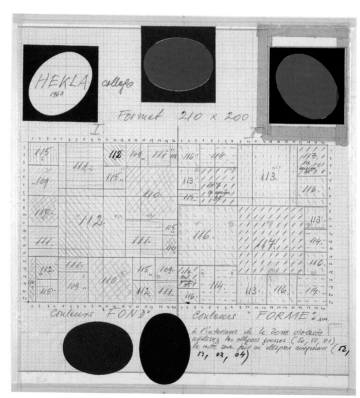

Hekla, 1963

List of Works

1. **Études Bauhaus (A, B, C, and D)**
 1929
 Oil on board
 9 x 9 in. (23 x 23 cm) each
 Collection of Michèle-Catherine Vasarely

2. **Autoportrait**
 1934
 Pastel on paper
 22 x 14⅛ in. (56 x 36 cm)
 Collection of Michèle-Catherine Vasarely

3. **Étude de Mouvement**
 1935
 Pencil on paper
 19¼ x 20⅞ in. (49 x 53 cm)
 Private collection

4. **Étude Lineaire**
 1935
 Gouache on board
 15 x 22⅞ in. (38 x 58 cm)
 Private collection

5. **L'Échiquier**
 1935
 Oil on board
 24 x 16⅛ in. (61 x 41 cm)
 Private collection

6. **Étude Lineaire**
 1935
 Ink on paper
 24 x 15¾ in. (61 x 40 cm)
 Collection of Michèle-Catherine Vasarely

7. **Arlequin**
 1936–52
 Oil on canvas
 46⅞ x 30 in. (119 x 76 cm)
 Collection of Michèle-Catherine Vasarely

8. **Zèbres**
 1937
 Ink on board
 20½ x 23⅝ in. (52 x 60 cm)
 Private collection

9. **Tigres**
1938
Oil on canvas
32¼ x 48 in. (82 x 122 cm)
Private collection

10. **Étude en Jaune**
1940
Oil on board
23⅝ x 21⅝ in. (60 x 55 cm)
Private collection

11. **Étude en Rouge**
1940
Oil on board
23⅝ x 21⅝ in. (60 x 55 cm)
Private collection

12. **Étude en Multicolore**
1941
Oil on board
23⅝ x 21⅝ in. (60 x 55 cm)
Private collection

13. **Le Cirque**
1942
Oil on board
28¾ x 26 in. (72 x 66 cm)
Collection of Michèle-Catherine Vasarely

14. **La Cuisine Jaune à Cocherel**
1946
Oil on wood
28⅜ x 35⅞ in. (72 x 91 cm)
Collection of Michèle-Catherine Vasarely

15. **La Maison**
1946
Oil on board
12½ x 11⅜ in. (32 x 29 cm)
Collection of Michèle-Catherine Vasarely

16. **Artiste Devant Sa Toile**
1947
Oil on canvas
18⅛ x 15 in. (46 x 38 cm)
Private collection

17. **Mi-Zèbre**
1948–64
Oil on canvas
36¼ x 45⅝ in. (92 x 116 cm)
Private collection

18. **Zèbre**
1950
Gouache on board
7⅞ x 14⅛ in. (20 x 36 cm)
Private collection

19. **Ézinor**
1949
Oil on board
15 x 11⅞ in. (38 x 30 cm)
Private collection

20. **Mar Caribe**
1950
Oil on board
18⅞ x 15¾ in. (48 x 40 cm)
Private collection

21. **Kandahar**
1950–52
Oil on pressed board
39⅜ x 42⅝ in. (100 x 108.3 cm)
Solomon R. Guggenheim Museum,
 New York (54.1396)

22. **Maranon**
1951
Oil on board
13 x 12¼ in. (33 x 31 cm)
Private collection

23. **Senanque-2**
1951
Oil on board
13⅜ x 12¼ in. (34 x 31 cm)
Private collection

24. **Banghor**
1951
Ink on layered parchment
25½ x 17¾ in. (65 x 45 cm)
Collection of Michèle-Catherine Vasarely

25. **Méandres Belle-Isle**
1951
Oil on canvas
59 x 40⅛ in. (150 x 102 cm)
Private collection

26. **Mindanao**
1952–55
Oil on canvas
64 x 51⅛ in. (162 x 130 cm)
Gift of Seymour H. Knox, 1958
Albright-Knox Art Gallery, Buffalo (K1958:45)

27. **Yvaral**
1956–65
Acrylic on canvas
82⅝ x 78¾ in. (210 x 200 cm)
Collection of Michèle-Catherine Vasarely

28. **Cassiopée-II**
1958
Acrylic on canvas
74¾ x 51⅛ in. (195 x 130 cm)
Private collection

29. **Binaire**
1960
Acrylic on canvas
76¾ x 51⅛ in. (195 x 130 cm)
Private collection

30. **Riu-Kiu-C**
1960
Acrylic on canvas
45¼ x 45¼ in. (115 x 115 cm)
Private collection

31. **Alphabet VB**
1960
Acrylic on canvas
63 x 59 in. (160 x 150 cm)
Private collection

32. **Alphabet VR**
1960
Acrylic on canvas
63 x 59 in. (160 x 150 cm)
Private collection

33. **Lux-Novae**
1962
Acrylic on canvas
74¾ x 51⅛ in. (190 x 130 cm)
Private collection

34. **Our-MC**
1964
Acrylic on canvas
13 x 12¼ in. (33 x 31 cm)
Collection of Michèle-Catherine Vasarely

35. **Naissance**
1964
Acrylic on canvas
70 x 60⅝ in. (178 x 154 cm)
Private collection

36. **Bora III**
1964
Oil on canvas
58¾ x 55½ in. (149.2 x 141 cm)
Gift of Seymour H. Knox, 1966
Albright-Knox Art Gallery, Buffalo (K1966:2)

37. **Majus-MC**
1967
Acrylic on board
20½ x 20½ in. (52 x 52 cm)
Private collection

38. **Yvalla**
1968
Acrylic on canvas
99⅝ x 83⅞ in. (253 x 213 cm)
Private collection

39. **Keple-Gestalt**
1968
Acrylic on canvas
63 x 63 in. (160 x 160 cm)
Private collection

40. **Torony-Nagy**
1969
Acrylic on canvas
78¾ x 78¾ in. (200 x 200 cm)
Private collection

41. **Orion Gris**
1969
Acrylic on canvas
78¾ x 78¾ in. (200 x 200 cm)
Private collection

42. **Vega-Nor**
1969
Acrylic on canvas
78¾ x 78¾ in. (200 x 200 cm)
Gift of Seymour H. Knox, 1969
Albright-Knox Art Gallery, Buffalo (K1969:29)

43. **Vega-Lep**
1970
Acrylic on canvas
59 x 59 in. (150 x 150 cm)
Private collection

44. **Vega-Miroir**
1974
Acrylic on canvas
55½ x 55½ in. (141 x 141 cm)
Private collection

45. **Vonal-Stri**
1975
Acrylic on canvas
78¾ x 78¾ in. (200 x 200 cm)
Private collection

46. **Dyevat**
1975
Acrylic on canvas
78¾ x 78¾ in. (200 x 200 cm)
Private collection

47. **Boglar-Ter**
1978
Acrylic on canvas
63 x 63 in. (160 x 160 cm)
Private collection

48. **Galaxie**
1979
Acrylic on canvas
70⅞ x 70⅞ in. (180 x 180 cm)
Private collection

49. **Tekers-MC**
1981
Acrylic on canvas
92½ x 79⅛ in. (235 x 201 cm)
Collection of Michèle-Catherine Vasarely

Chronology

Vasarely's birthplace in Pécs. The building today houses a museum.

1906
Born April 9 in Pécs, Hungary.

1925–27
Receives a bachelor's degree in 1925 and goes on to study medicine at the University of Budapest. Decides to abandon his medical studies after two years, though he later brings scientific methodology and objectivity to his approach to art.

1927–29
Studies art at the Podolini-Volkmann Academy in Budapest.

1929
Enrolls at Sándor Bortnyik's Mühely Academy, widely recognized as the center of Bauhaus studies in Budapest.

With his wife, Claire Spinner.
Arcueil, 1937.

1930–35

In September 1930, Vasarely settles in Paris, where he works as a graphic artist for various agencies, including Havas, and for the renowned printer Draeger. Begins his Zebra studies and engages in his first optical experiments. Marries Claire Spinner in 1931. Their first child, André, is born the same year. A second son, Jean-Pierre, is born in 1934.

1936–45

Assembles an important body of graphic work in which he develops the aesthetic foundations for his plastic language. Inaugurates the Denise René Gallery in 1944 with a one-man show and participates for the first time in "Salon des Surindépendants" in 1945.

1946–48

Moves decidedly toward Constructivist and geometric abstract art. His vacations at Belle-Isle and Gordes beginning in 1947 play an important role in inspiring this shift away from figurative representation. He experiments with the use of transparencies and color projections and produces some tapestries. Also publishes his first edition of prints. His work is again shown in "Salon des Surindépendants" in 1946 and, in 1947, it is shown for the first time in "Salon des Réalités Nouvelles." Participates in 1948 in "Tendances de l'Art Abstrait," an exhibit at the Denise René Gallery in Paris.

1952–59

Introduces new materials, such as aluminum and glass, and completes a series of murals for the University of Caracas in Venezuela as well as several architectural integrations,

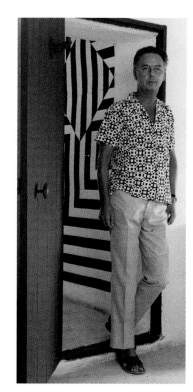

In his summer home. Gordes, 1958.

such as *Hommage à Malévitch*. Vasarely's "Manifeste Jaune," which is published in 1955, receives the Critics Award in Brussels and the Gold Medal at the Milan Triennial. Participates in numerous exhibits, including "Le Mouvement" (1955) at the Denise René Gallery, "50 Ans d'Art Moderne" (1958) at the Palais International des Beaux-Arts in Brussels, and "Inaugural Selection" (1959) at the Solomon R. Guggenheim Museum in New York. He has solo exhibitions at the Buenos Aires and Caracas museums of art and also at Der Spiegel Gallery in Cologne.

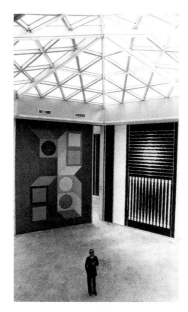

In his studio with Werner Spies. Annet-sur-Marne, 1970.

1960–65

Receives the International Guggenheim Award in New York and the Grand Prix de la Gravure in Ljubljana, Slovenia. Vasarely is also honored with the Chevalier de l'Ordre des Arts et Lettres in Paris and with the Grand Prize at the VIII Art Biennale of São Paolo. Participates in numerous collective exhibits, including "Documenta III" in Kassel, Germany (1964), and, most notably, "The Responsive Eye" at the Museum of Modern Art in New York. Also participates in many solo exhibitions, among them shows at the Musée des Arts Décoratifs in Paris (1963), the Palais des Beaux-Arts in Brussels (1965), the Pace Gallery in New York (1965), and in Bern at the Kunsthalle (1965).

Inside the Vasarely Foundation. Aix-en-Provence, 1976.

1966–69

Completes several architectural projects, including one for the French pavilion at the Montreal world's fair in 1967, and two films, *Les Multiples* and *Précinetisme*. Among his numerous exhibits are "Lumière et Mouvement" at the Musée d'Art Moderne de la Ville de Paris (1967) and "10 Ans d'Art vivant, 1955–65" at France's Fondation Maeght (1968). He has a one-man show, "Folklore Planetaire," at the Denise René Gallery and, in 1969, a

retrospective at the Museum of Fine Arts in Budapest. Interviews of the artist by Jean-Louis Ferrier are published.

1970–75

The Vasarely Museum in Gordes, France, is inaugurated in 1971. He publishes the four-volume *Plasti-cité* and receives the International Art Book Award for two of the volumes in 1971 and 1975. Designs the set for the Racine opera *Bérenice,* performed in Hungary.

1976–82

Inauguration of the Vasarely Foundation in Aix-en-Provence (1976) and the Vasarely Museum in Pécs, his hometown (1978). Has a one-man show at the Caracas Museum of Contemporary Art (1977) and at the Phoenix Art Museum (1979). Creates 154 prints that are transported into space aboard the Soyuz 7 by a French-Soviet team of cosmonauts.

1984–90

Named Honorary Citizen of the City of New York and delivers a series of lectures in the United States. In France, Vasarely is named Officier de l'Ordre des Arts et des Lettres (1985) and promoted to the rank of Grand Officier de l'Ordre du Mérite (1990). Inauguration of the Vasarely Museum at the Zichy Palace in Budapest (1987).

1997

Dies March 15 in Paris.

Selected Bibliography

Diehl, Gaston. *Vasarely.* Translated by Eileen B. Hennessy. New York: Crown Publishers, 1972.

Gassen, Richard W. *Vasarely: Erfinder Der Op-Art.* Exhibition catalog. Ostfildern: Verlag Gerd Hatje, 1998.

Lippard, Lucy R., and John Chandler. "The Dematerialization of Art." In *Changing: Essays in Art Criticism,* pp. 255–76. New York: Dutton, 1971.

Rickey, George. *Constructivism: Origins and Evolution.* New York: George Braziller, Inc., 1967.

Robert Sandelson Modern and Contemporary British and International Art Gallery. *Victor Vasarely.* Exhibition catalog. London: Robert Sandelson, 2003.

Schröder, Klaus Albrecht. *Victor Vasarely.* Exhibition catalog. Munich: Prestel, 1992.

Seitz, William C. *The Responsive Eye.* Exhibition catalog. New York: The Museum of Modern Art, 1965.

Spies, Werner. *Vasarely.* Exhibition catalog. Madrid: Fundación Juan March, 2000.

———. *Victor Vasarely.* New York: Harry N. Abrams, 1971.

Victor Vasarely: 50 Years of Creation. Exhibition catalog. Lausanne: Musée Olympique, 1995.

Vasarely Inconnu. Exhibition catalog. Fécamp, France: Palais Bénédictine, 2001.

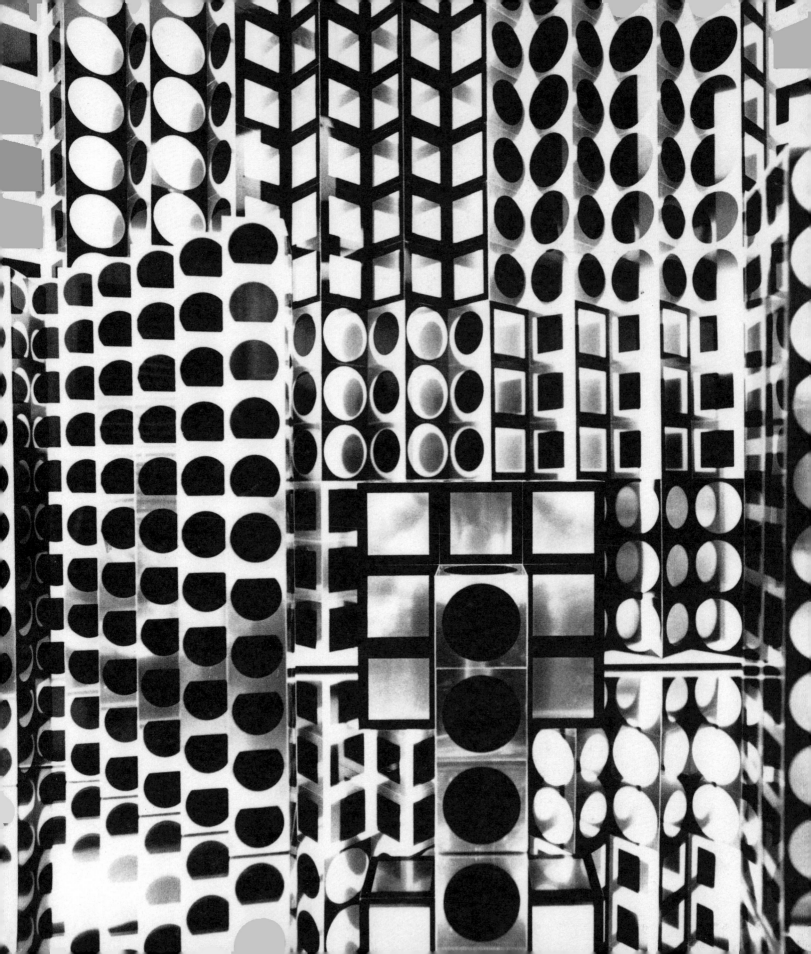